HOW TO DRAW MANGA

volume 2

Compiling Techniques

HOW TO DRAW MANGA Volume 2: Compiling Techniques
by The Society for the Study of Manga Techniques

Copyright © 1996 The Society for the Study of Manga Techniques
Copyright © 1996 Graphic-sha Publishing Co., Ltd.

First published in 1996 by Graphic-sha Publishing Co., Ltd.
This English edition was published in 2001 by
Graphic-sha Publishing Co., Ltd.
1-9-12 Kudan-kita, Chiyoda-ku, Tokyo 102-0073, Japan

Representative Members of The Society for the Study of Manga Techniques:
Hideki Matsuoka, Tatsuhiro Ozaki, Takehiko Matsumoto, Hiroki Ono
Planning: Hideaki Matsuoka
Original cover drawing: Ganma Suzuki
Cover design: Hideyuki Amemura
Photography: Yasuo Imai
English edition layout: Shinichi Ishioka
English translation: Christian Storms
Translation management: Língua fránca, Inc. (an3y-skmt@asahi-net.or.jp)
Japanese edition editor: Motofumi Nakanishi (Graphic-sha Publishing Co., Ltd.)
Foreign language edition project coordinator: Kumiko Sakamoto (Graphic-sha Publishing Co., Ltd.)

Distributor:
Japan Publications Trading Co., Ltd.
1-2-1 Sarugaku-cho, Chiyoda-ku, Tokyo, 101-0064 Japan
Phone: 81-3-3292-3751 Fax: 81-3-3292-0410
E-mail: jpt@jptco.co.jp

First printing: July 2000
Second printing: September 2000
Third printing: June 2001
Fourth printing: August 2001
Fifth printing: November 2001
Sixth printing: March 2002

ISBN: 4-88996-044-9
Printed and bound by Everbest Printing Co., Ltd. in China

volume 2

Compiling Techniques

Table of Contents

The Aim of Volume Two..6

Learning from Your Mistakes - An Assistant's Day in the Life Diary........................7

Chapter 1 - Background Management Basics..15

Manga Background Management ...16

Drawing Effect Lines ..20

 Parallel Lines / Emphasis Lines / How to Make All Black Flashes / Curved Lines

 Using a Draftsman's Ruler

Non-Effect Line Background Management ..28

 Shift - Double Pass Parallel and Diagonal Lines / Triple Pass Parallel Lines /

 Haze / Rope Patterns / Scattering from the Focal Point / Pointillist Sketching /

 Spattering / Patting / Lightening Flashes

Linear Perspective - How to Draw Basic Backgrounds32

 Point of View (POV) / How to Draw One-Point Perspective / How to Draw Two-

 Point Perspective / How to Draw Three-Point Perspective / Deformed

 Perspective / Trick - 'Damashi' in Japanese - One-Point Perspective

Drawing Backgrounds by Tracing Photographs48

Drawing Circles in Perspective ...50

Chapter 2 - Tone Techniques ...51

Tone Types...52

Tone Tools ..54

How to Apply Tones..56

How to Etch Tones...58

 Freehand Etching Using a Cutter

Tip Cutting and Etching / Etching with the Back of the Tip / Etching with the Back of the Blade / Tap Etching with the Back Tip / How to Etch Clouds

Etching With a Ruler

Cutter Blade Angles / Notes of Caution / Lightening Flashes / Etching Inward / Tone Flashes

Etching with a Sand Eraser

Layering Tones ...80

Using White Tones ...86

Various Expressions Using Tones ..88

Expressing Trees and Forests / Expressing Deserts / Expressing Bodies of Water / Expressing Fire, Flames and Explosions / Expressing Metals and Jewelry / Expressing Lightening

Expressing Visual Direction Effects Using Tones94

How to Use Illust Tex and Instantex ..96

Other Tone Techniques ...98

Chapter 3 - Expressing Light and Shadows...99

Light and Shadows in Manga ..100

Expressing Shadows and Light in Manga ..102

Basic Solid Form Object Shadows..104

Drawing Shadows on Characters' Faces ...106

How to Draw Shadows on a Variety of Faces..108

Shadows Cast on the Body..110

Shadows Cast on the Ground ..114

Shadows Cast in Exterior Settings..116

Expressing Interior Light and Shadows..118

The Aim of Volume Two

How should tones be cut in the background of a manga page? How should I hold a cutter? And at what angle?

Have you, the reader, ever seen a book before that answers all the questions to techniques you have been dying to know?

Well, here is the book you have been looking for covering the fundamental techniques you have been longing for with easy to understand and in depth content. Building on Volume One 'Creating Characters' we have included everything you need to know to create your frames.

This book is aimed at a wide audience from first timers to advanced users who have hit a wall in their work but mainly for people who want to improve their manga techniques from school children to adults.

Centering around how to draw backgrounds, this volume covers the indispensable techniques for filling frames - effect lines, flashes, perspective, tone techniques, expression of light and shadows with extremely thorough examples and explanations especially for tones.

With this one book, your manga ability will improve beyond belief.

Note: Works referenced in this book have been recreated to look like the original as best as possible; however, due to the lack of space, in some cases the works have been greatly reduced in size. For further study of more complete details, we recommend referring to the works as published in their original forms.

Learning from Your Mistakes
An Assistant's Day in the Life Diary

By Hideki Matsuoka

Note : All MANGA in this book are in their original layout. Please read from right to left.

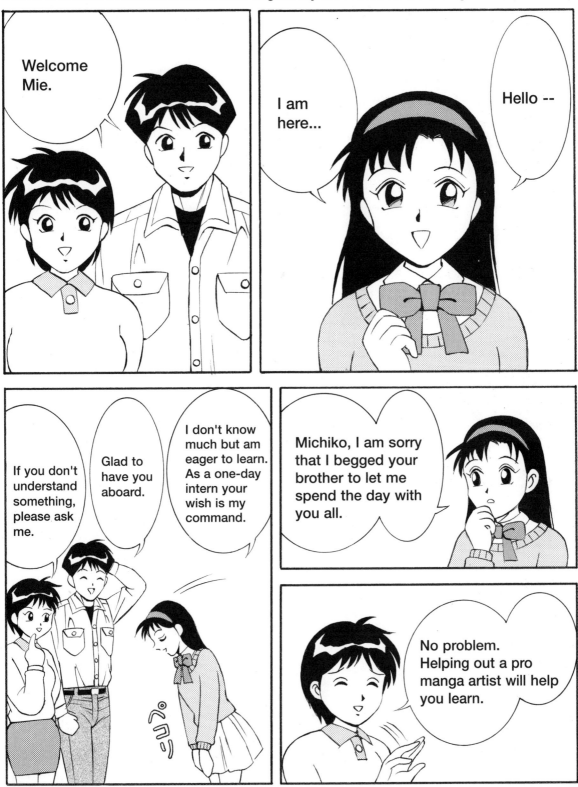

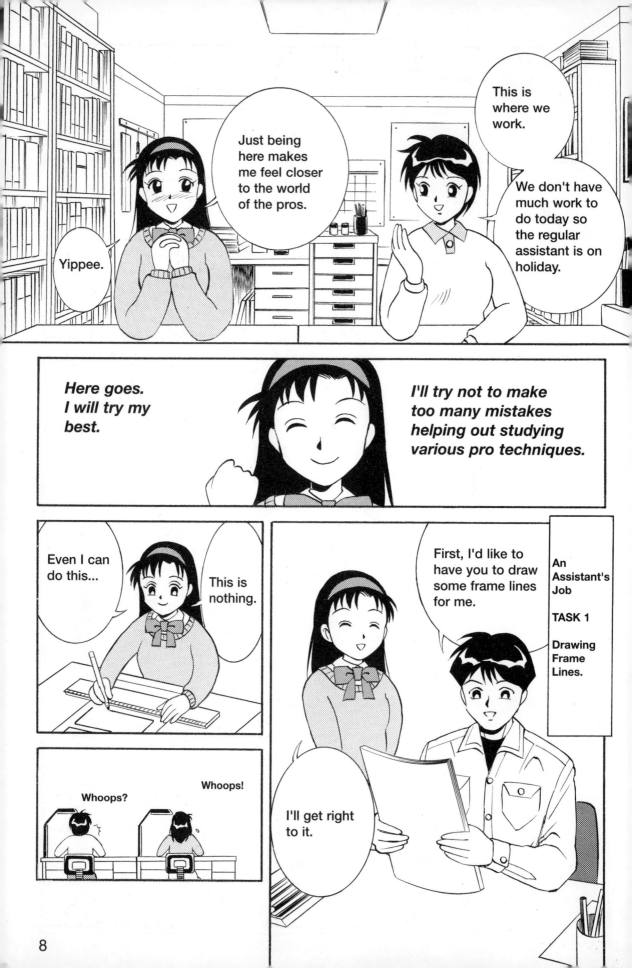

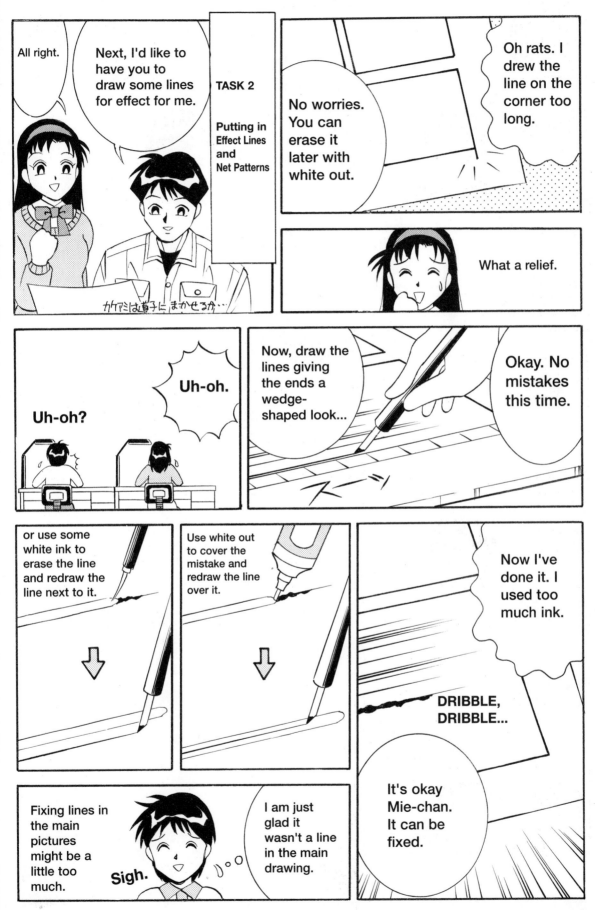

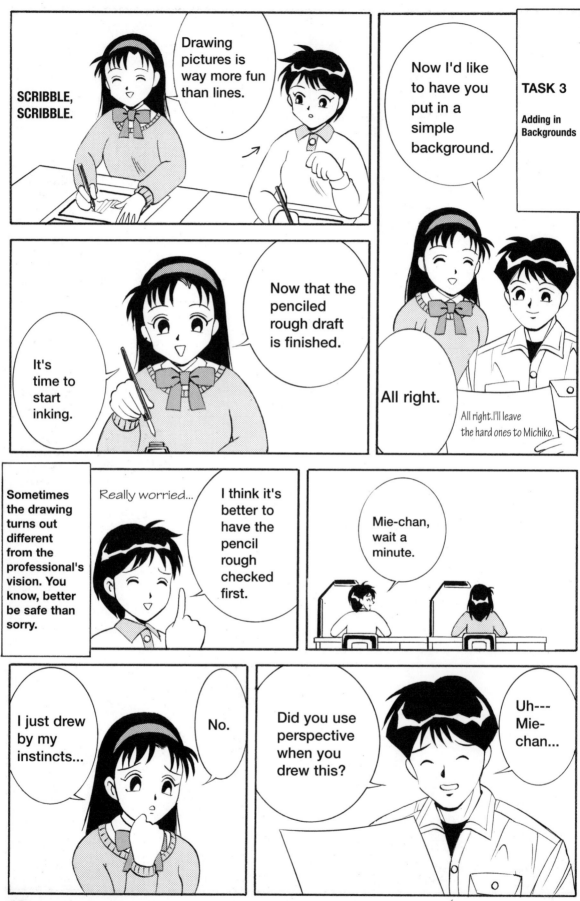

10

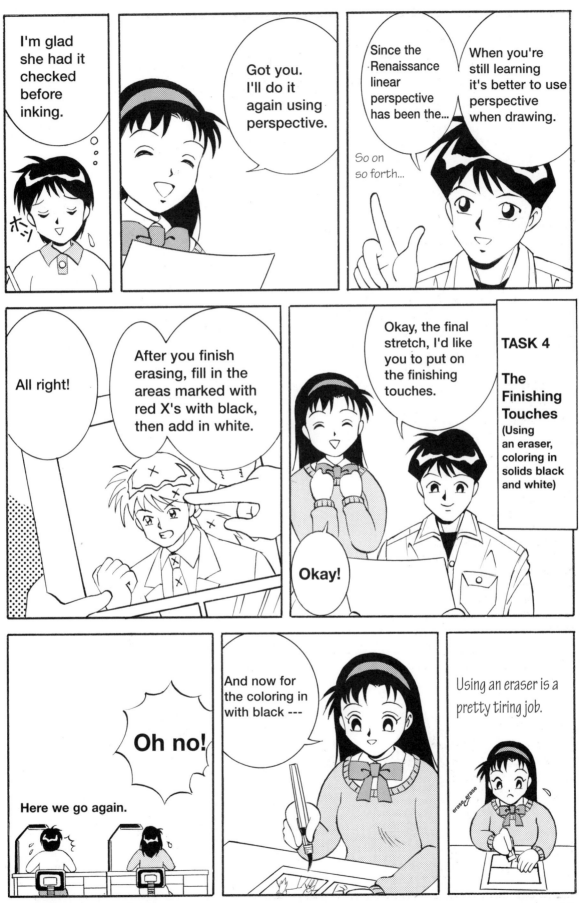

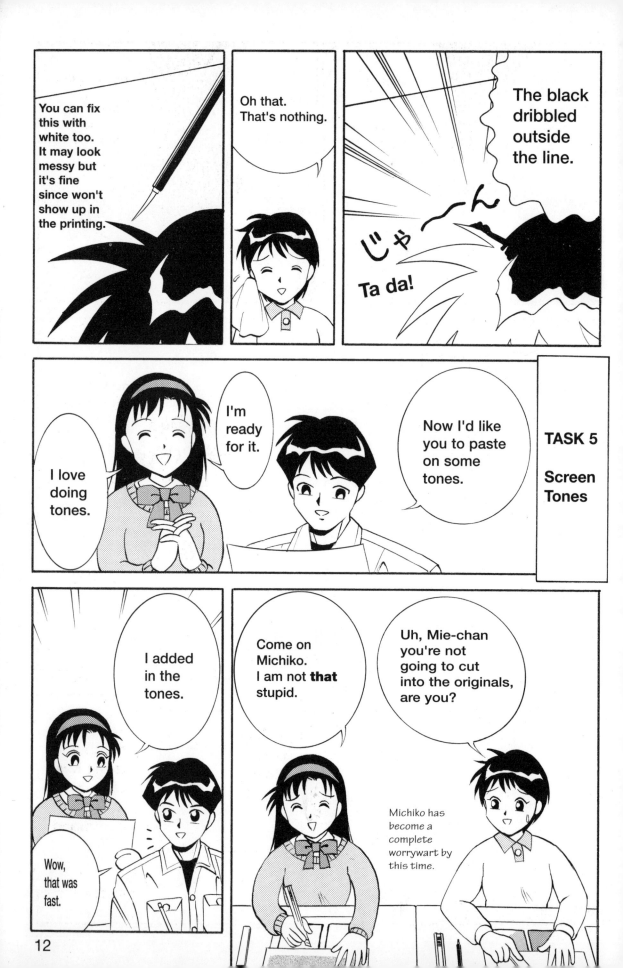

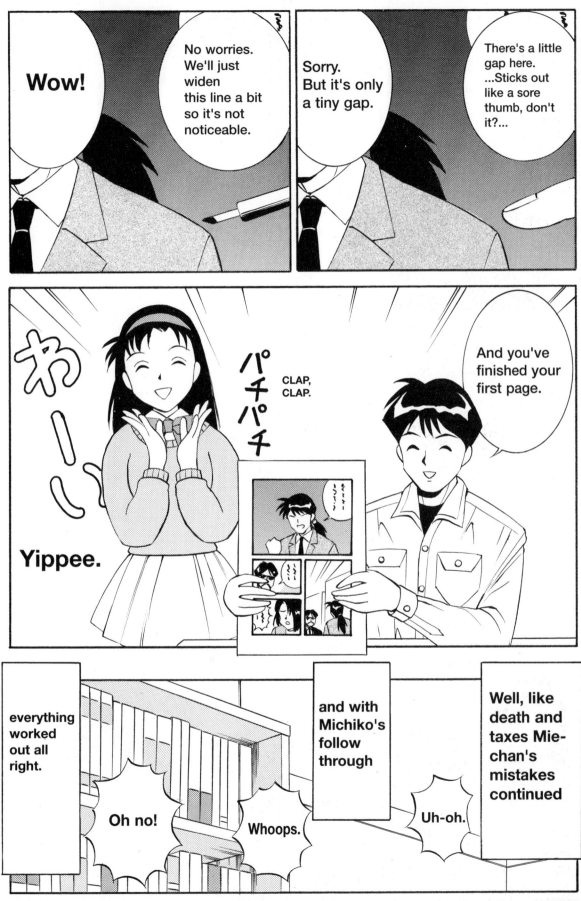

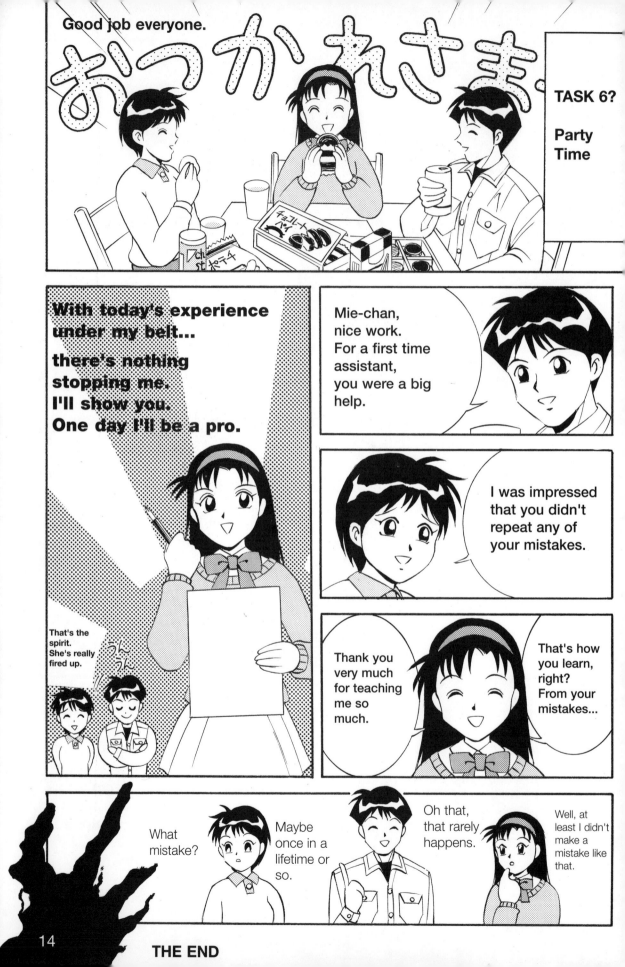

Chapter 1
Background Management Basics

Manga Background Management

Manga characters move amid frames. Everything inside the frame except for the character is known as the background. Here, things like buildings, with specific backgrounds and effect lines, convey where the character is, how she is feeling, what she is doing, etc., to the reader.

Background usage can be broken down into three general categories.

1. Lines for Effect

2. Lines for Direction

3. Specific Backgrounds

These are explained in plain terms below.

1. Lines for Effect

'Speed Lines' can be defined as straight and curved lines for the purpose of calling attention of the character's movement and emotions to the reader.

a. Parallel Speed Lines

Vertical lines can also be added in.

High Kick!!

Head Smash!!

Use of speed lines

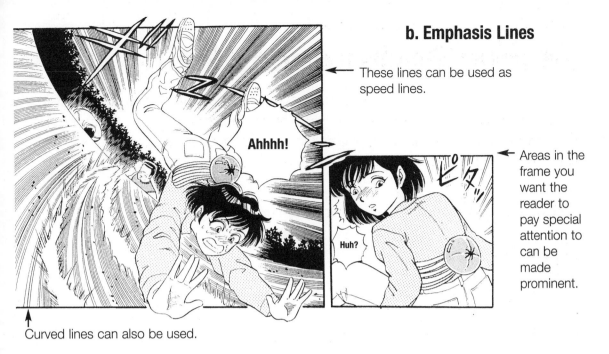

← These lines can be used as speed lines.

Ahhhh!

Huh?

← Areas in the frame you want the reader to pay special attention to can be made prominent.

↑ Curved lines can also be used.

2. Lines for Direction

Pen touch techniques like net patterns, pointillist sketching, pasting and erasing of tones, are some of the many methods of directing a character's emotions and his current state of affairs. In order to create a certain atmosphere, of course leaving the background white works too as this is also one variety of visual direction.

a. Pen Touches

This manga uses haze - 'moya' in Japanese - pen touches in the background to create a burning look adding intensity to the scene.

b. Tones

This is a tone flash.
This technique uses a cutter to erase the tone giving it a flash effect.

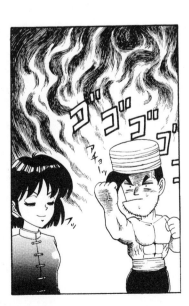

Thanks to you...
I was able to realize my inexperience.

© Yagami Yu/Media Works/Dengeki Comics Gao!
"ERUFU WO KARU MONOTACHI"

3. Specific Backgrounds

This involves drawing in detail the appearance of scene interiors and exteriors. While this example is more involved than the ones on page 16 and 17, it is necessary to have the reader understand the what, where, when and why of character's environment.

a. Interiors

b. Exteriors

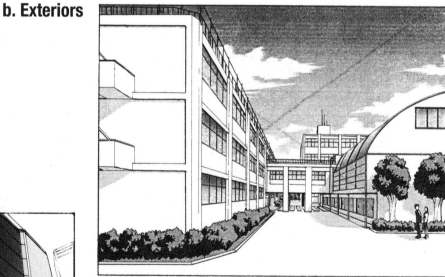

A school drawn with one-point perspective.

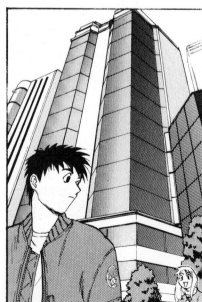

background in a skyscraper scene

Three-point perspective brings out the sense of height.

Nature backgrounds like stars can also be used.

As punishment and for introspection you'll be locked away in the cabin for a while.

Buildings laid in ruin often appear in sci-fi manga.

For Manga, it is important to find a balance in background management.

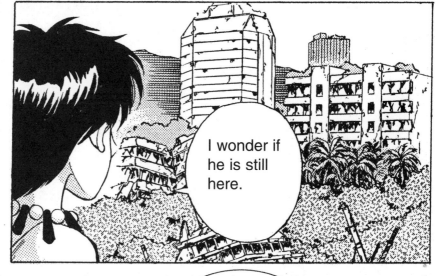

I wonder if he is still here.

Strive for a balance with manga with well-planned drawings that are easy to read and understand for the reader.

If you use too many effect lines, people will say that your manga lacks detail.

And if you use too many backgrounds, the drawings get confused and hard to see.

19

Drawing Effect Lines

Effect lines can be divided into three groups: parallel lines, emphasis lines and curved lines using a draftsman's curve ruler.

Parallel Lines

Lines were drawn using a ruler.

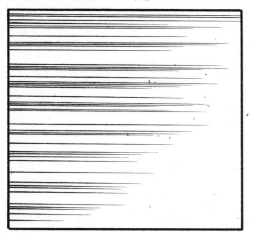

An example often used to show movement using speed lines. You can show the difference in the sense of the speed based on the density of the lines. The sense of speed gets faster with the more lines you draw.

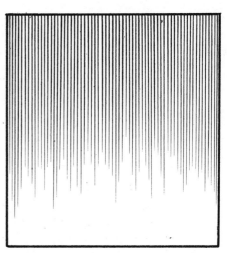

Lines hanging from the top are often used to show a character's depressed mental state.

<How to Draw Parallel Lines>
To prevent the line from slipping, use a graph scaled ruler.
If you don't have one, draw guidelines in pencil as a yardstick beforehand.

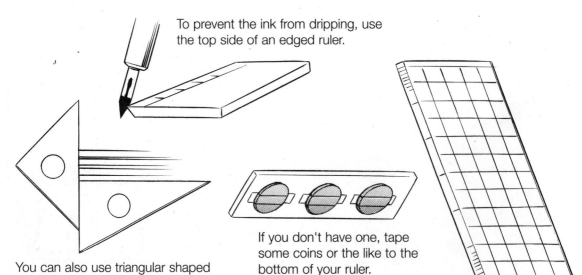

To prevent the ink from dripping, use the top side of an edged ruler.

You can also use triangular shaped rulers placed together like this.

If you don't have one, tape some coins or the like to the bottom of your ruler.

Parallel lines can fill the entire frame or can disappear mid-frame and be mixed with emphasis lines.

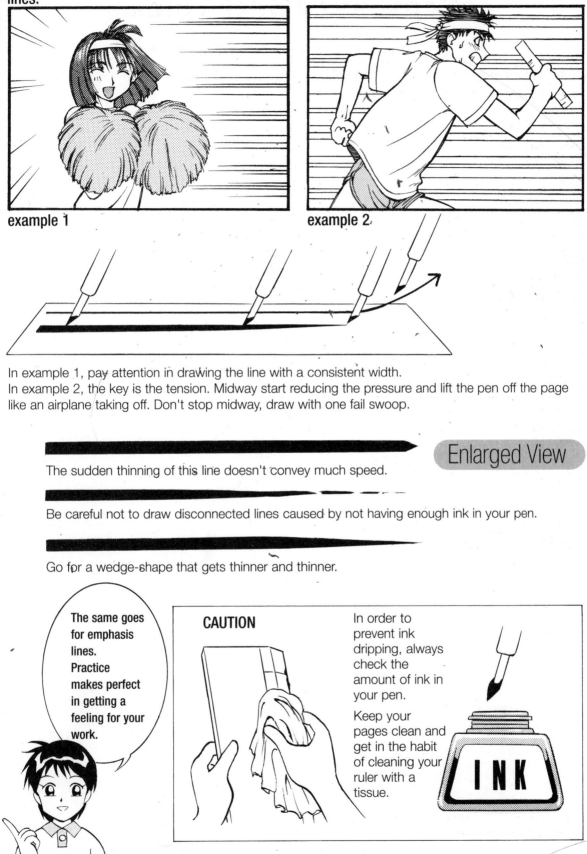

example 1

example 2

In example 1, pay attention in drawing the line with a consistent width.
In example 2, the key is the tension. Midway start reducing the pressure and lift the pen off the page like an airplane taking off. Don't stop midway, draw with one fail swoop.

Enlarged View

The sudden thinning of this line doesn't convey much speed.

Be careful not to draw disconnected lines caused by not having enough ink in your pen.

Go for a wedge-shape that gets thinner and thinner.

The same goes for emphasis lines. Practice makes perfect in getting a feeling for your work.

CAUTION

In order to prevent ink dripping, always check the amount of ink in your pen.

Keep your pages clean and get in the habit of cleaning your ruler with a tissue.

INK

Decide on a focal point and draw your lines toward it.
As one variety of emphasis lines,
all black flash lines work well too.

<How to Draw Emphasis Lines>

Emphasis lines can also be used as speed lines.

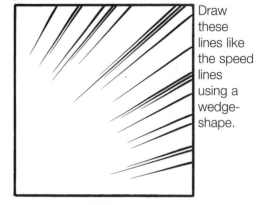

Draw these lines like the speed lines using a wedge-shape.

The overall feel changes depending on the density of the lines. ⬆️
⬇️

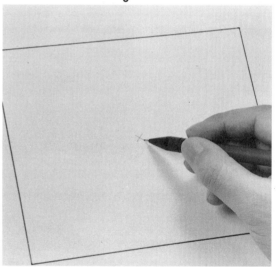

1) Pick a focal point and mark it with an X.

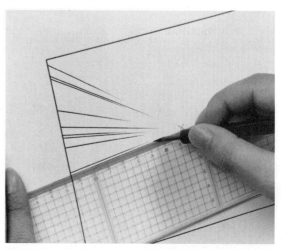

2) Put the edge of the ruler on the focal point and draw a line.

Using a Thumbtack

When the emphasis lines increase, drawing lines with a ruler placed in the middle becomes a little hectic.

Sticking a thumbtack in the focal point makes lining the ruler up a lot easier.

There are three ways to place the thumbtack.

CAUTION:
If the glue on the tape is too strong, it will rip the page when removed. Weaken the glue with your fingers or better yet use drafting tape.

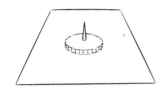

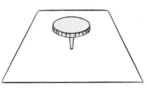

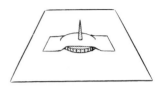

1) Point Up

While this is the fastest way, the part of the page around the thumbtack expands which can cause ink drips.

2) Point Down with a notepad below

Place a notepad and the like under your page and push in the thumbtack. This method leaves the least amount of ink drips.

3) Using Tape

Tape can be used to stabilize the thumbtack. While it prevents poking a hole in the page, watch out for ink drips.

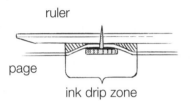

ruler

page

ink drip zone

Place the tape over the thumbtack using the extra bits to fasten to the page.

When the focal point won't fit on the page, use an extra page like this to draw your lines.

Always close up the thumbtack hole with white.

If you don't, the hole will show up in the printing.

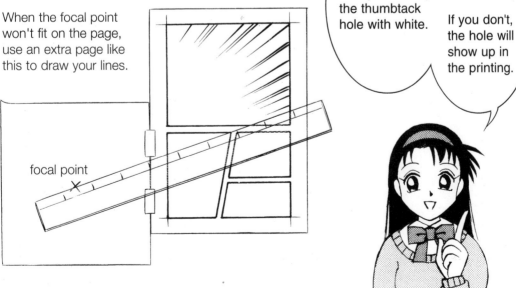

focal point

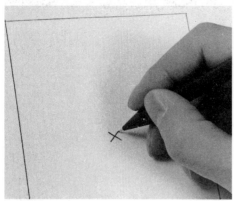

1) Pick a focal point
Mark it with an X.

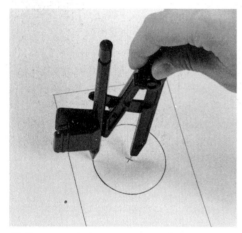

2) Draw a circle
Draw a circle around the focal point as a yardstick. Freehand drawing is fine but for those of you who want to do it right, use a compass or circular ruler.

3) Use a thumbtack
Place the tack in the focal point. The thumbtack is placed over the page so not to smug the ink.

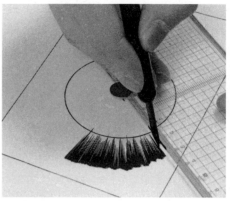

4) Draw the lines
Paying attention not to have the ruler slip away from the thumbtack, draw the lines. This example uses a round pen.

Use pressure at first then gradually less pressure lifting the pen off the page. Be mindful to draw wedge-shaped lines.

Be careful not to leave spaces between the lines. If there are any gaps, use a pen to fill them in later.

Not enough ink. Draw the line again.

If the lines are badly-shaped, use some white-out and draw the line again.

With too much ink in the pen, the lines will run together. With too little ink, the lines become disconnected midway through.

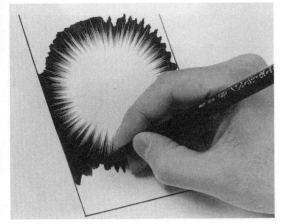

5) Fill in the outside with black
After using an eraser, add in black. Fit the gaps at this time.

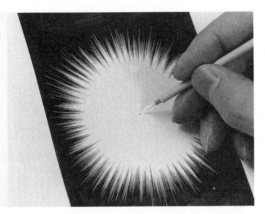

6) Touch up with white
Fill the thumbtack hole in with white.

7) Finished Work

Practical Applications

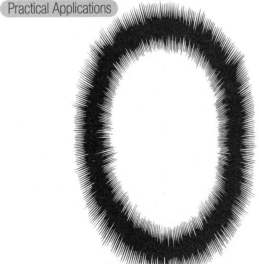

dialogue balloon flash

Commonly called sea urchin - 'uni' in Japanese - or millipede - 'gejigeji' in Japanese - dialogue balloons.
Flashes are used on both the interior and exterior.

lightening flash

This is often used when the character is extremely surprised. Several small black flashes, with lightening draw with white is a difficult technique. Tones like this can be purchased commercially.

25

Curved Lines Using a Draftsman's Ruler

Circular lines can be drawn using a curved ruler.

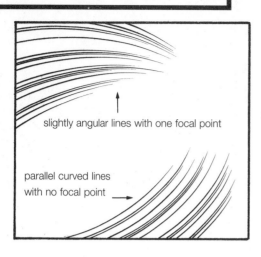

slightly angular lines with one focal point

parallel curved lines
with no focal point →

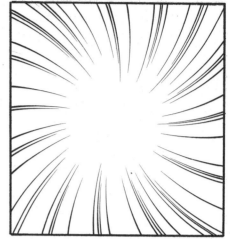

They can be used as speed lines as well as to
show character movement.

<How to Draw Curved Lines Using a Draftsman's Ruler>

Decide which part of the
draftsman's ruler to use by lining it
up with the curves in the existing
lines or draw it freehand. Use the
same amount of force when
drawing lines with an ordinary ruler.

Curved lines with a little perspective

With no set focal point, draw by instinct
using perspective.

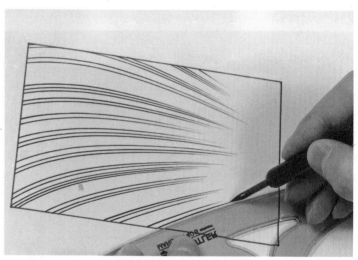

Parallel Curved Lines

Keeping the lines in position by using
the same part of the ruler.

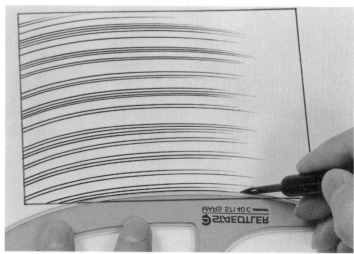

Curved Emphasis Lines

Be careful when using a curved ruler as changes in the point of contact with the focal point cause changes in the curves of the lines.

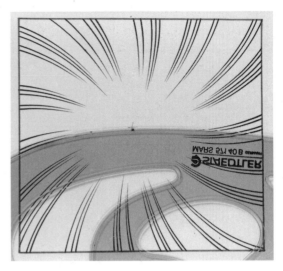

a. Marking the ruler's point of contact

Use a water paint marker or something similar to mark the ruler being careful not to shift the focal point drawing the lines.

b. Stabilizing the point of contact with tape.

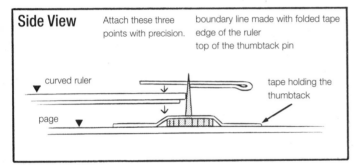

Side View

Attach these three points with precision.

boundary line made with folded tape
edge of the ruler
top of the thumbtack pin

curved ruler

tape holding the thumbtack

page

1) Fold a piece of tape as shown below.

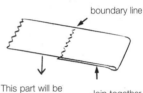

boundary line

This part will be attached to the focal point.

Join together the two folds.

This way emphasis lines can be drawn without worrying about the focal point shifting.

2) Attach it to the ruler like this.

Make sure the edge of the ruler and the boundary line fit perfectly.

3) Stick it through the thumbtack attached beforehand on your page.

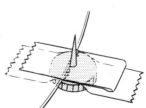

Note that the thumbtack is attached with another piece of tape.
Make sure the ruler, boundary line and the pin on the thumbtack line up perfectly.

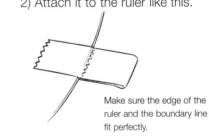

Non-Effect Line Background Management

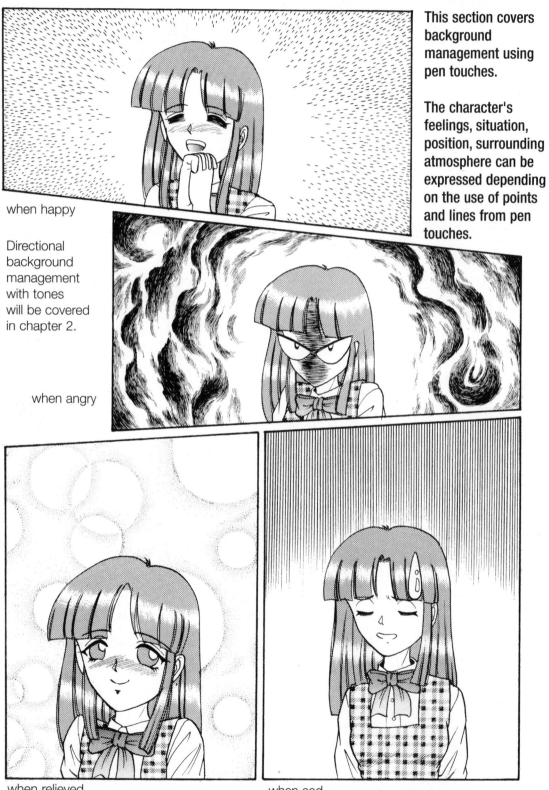

when happy

This section covers background management using pen touches.

The character's feelings, situation, position, surrounding atmosphere can be expressed depending on the use of points and lines from pen touches.

Directional background management with tones will be covered in chapter 2.

when angry

when relieved

when sad

There are many varieties of effect backgrounds.

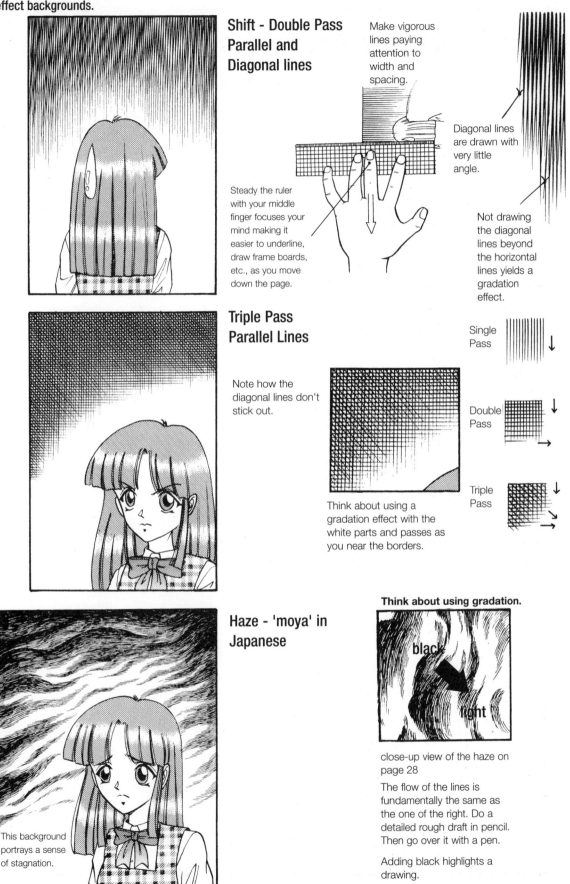

Shift - Double Pass Parallel and Diagonal lines

Make vigorous lines paying attention to width and spacing.

Steady the ruler with your middle finger focuses your mind making it easier to underline, draw frame boards, etc., as you move down the page.

Diagonal lines are drawn with very little angle.

Not drawing the diagonal lines beyond the horizontal lines yields a gradation effect.

Triple Pass Parallel Lines

Note how the diagonal lines don't stick out.

Single Pass

Double Pass

Triple Pass

Think about using a gradation effect with the white parts and passes as you near the borders.

Haze - 'moya' in Japanese

This background portrays a sense of stagnation.

Think about using gradation.

black

light

close-up view of the haze on page 28

The flow of the lines is fundamentally the same as the one of the right. Do a detailed rough draft in pencil. Then go over it with a pen.

Adding black highlights a drawing.

Net patterns can not only be used for mental states but also as background shadows.

While most patterns are sold commercially, be careful as the size of the line can make or break your manga.

Change the angle.

Follow the flow of your penciled rough draft.

After doing this, add more like on the left.

Do a detailed rough draft of the flow in pencil.

Rope Pattern

Then, based on the rough draft add in the rest keeping balance in mind.

Do a penciled rough of your flow from a focal point.

Scattering from the Focal Point

Then following your rough outline, add in the points. Start off slow, making each mark count, adding the detail you want.

First with a circular ruler decide in pencil what size of circle to add in.

Pointillist Sketching

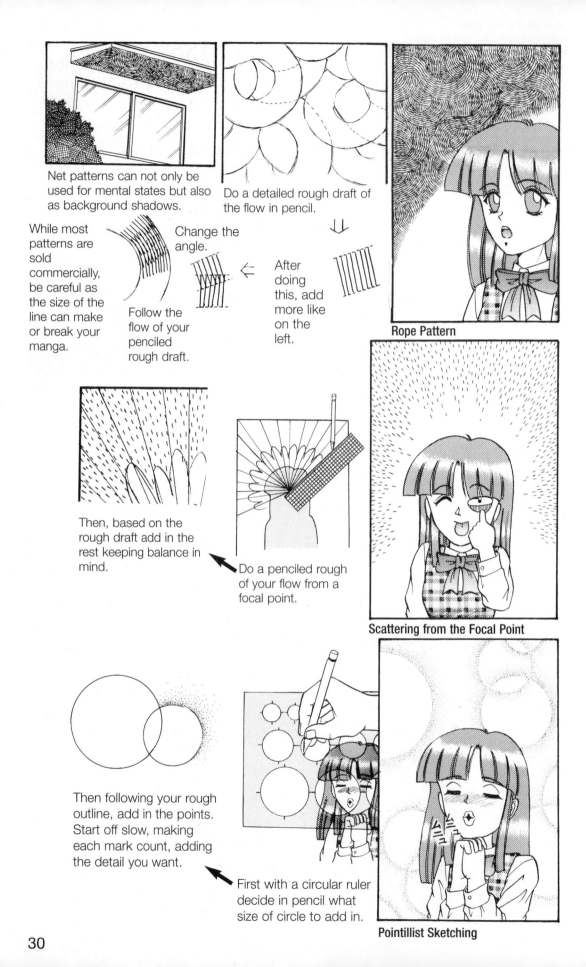

For gradation spattering, put white on a brush and brush into the mesh.

SQUISH, SQUISH

ゴシゴシ

For spattering the above gradation screen and brush are used.

Cover unwanted areas with masking tape or cover with tone paper. Use glue for the tone paper just like when adding in tones.

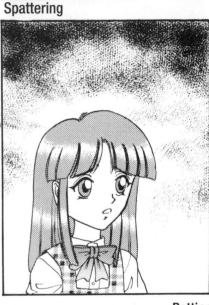

Spattering

Wrap absorbent cotton (or cotton balls) in gauze.

ポンポン

Make a 'teruteru boozu' adding ink.

Try not to cover the edges of the frame too much. Pick a variety of place to add this effect.

Try it first on other pages to get a feel for it when adding this effect.

Patting
(called 'teruteru boozu' in Japanese)

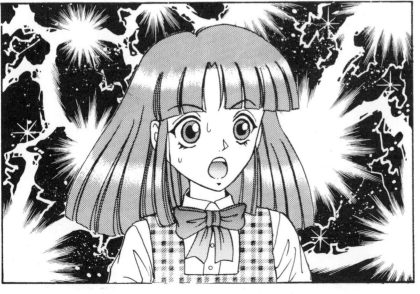

Lightening flashes
See chapter 2, page 25.

Linear Perspective ('paasu' in Japanese)
How to Draw Basic Backgrounds

The key to backgrounds is a sense of perspective. Things close up look big and things far away look small. Backgrounds not only include scenes of nature but also buildings and interiors. If not draw with care, they won't look professional. To look like a pro, use linear perspective.

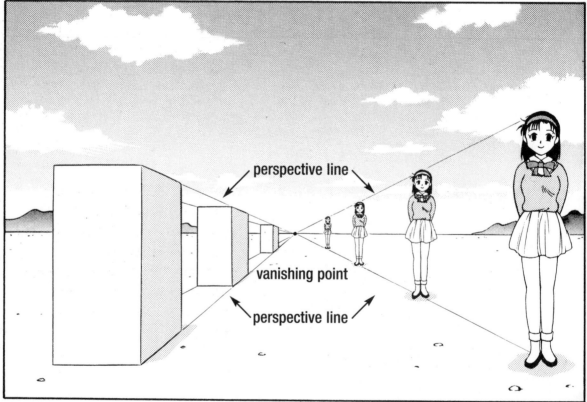

perspective line

vanishing point

perspective line

Objects on a horizontal plane become smaller and smaller as they reach a vanishing point.
The proportion of smallness radiates from the vanishing point along the extended perspective lines.
In addition, the height of the horizontal plane is normally from eye level.

With an opened-view, choose a vanishing point. Radiate lines of perspective from that point and draw in the contour of buildings, etc., along these lines.

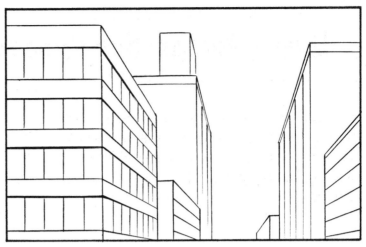

Drawn with one-point perspective. Good example.

The same picture drawn with no perspective. Bad example.

The Japanese word 'paasu' comes from the English word 'perspective.' Terms like in perspective and out of perspective are used.

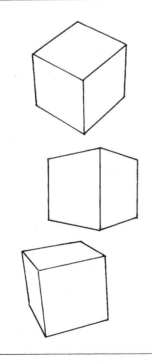

Drawing Squares and Cubes

There are methods for drawing squares and cubes in perspective. For those interested, please consult a book on perspective.
In manga, things are drawn by eye and instincts so spend time sketching everyday objects for practice.

Depending on the number of vanishing points,
one-point, two-point and three-point
perspective can be drawn.

one-point perspective

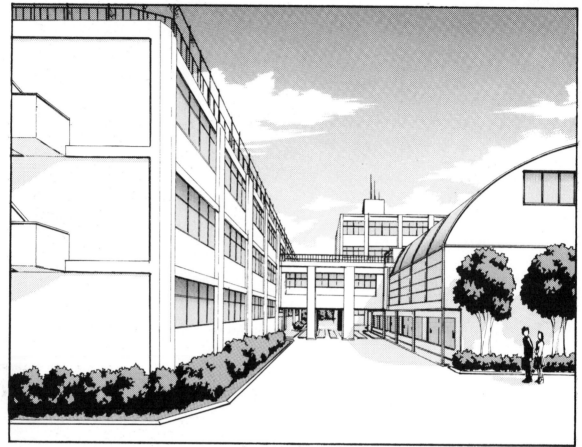

two-point perspective

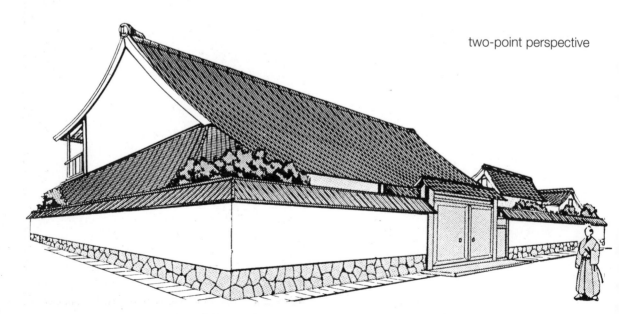

One and two-point perspective are the most often used and easiest to draw. As three-point perspective is more difficult to draw, this technique is reserved for large frames with powerful images.

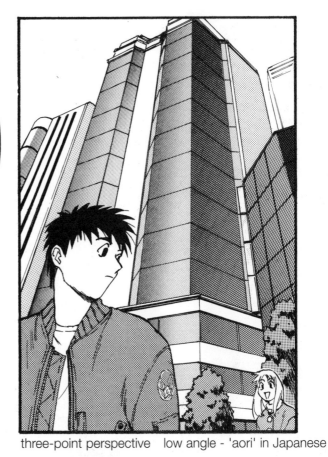

three-point perspective low angle - 'aori' in Japanese

As vanishing points can't be found for small objects placed on a desk, use contour lines to draw.
Also, to make small spaces look big use trick one-point perspective - 'damashi itten paasu' in Japanese (see page 46 for reference).

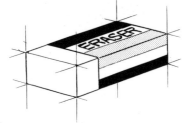

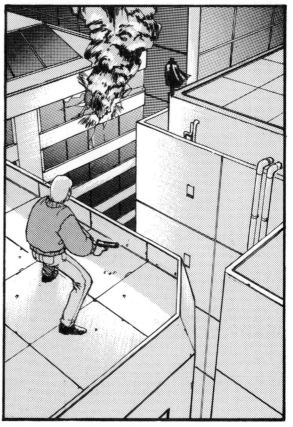

high angle - 'fukan' in Japanese

Point of View (POV)

low angle

In manga, the most often used POV is composition viewed from eye-level of the character.

However, if all of the frames are from eye-level the result is a monotone look. Try a variety of looks - compositions looking up and down (i.e. high and low angles).

eye-level

high angle

high angle composition

This gives the feel of a tall person looking down.
In this case, the ceiling is out of frame and portions of the floor can be seen.

eye-level composition

This gives the feel that the character looking at someone of the same height.
Depending on the distance from the wall behind, portions of the ceiling can be seen or not seen. Set in a hallway, the floor will come into view in the distance.

low angle composition

This gives the feel of a tall person looking down.
In this case, the ceiling is out of frame and portions of the floor can be seen.

This low angle composition accents the height of the buildings in the background.

Too many low and high angles make for hard reading

so use them with a certain purpose in mind.

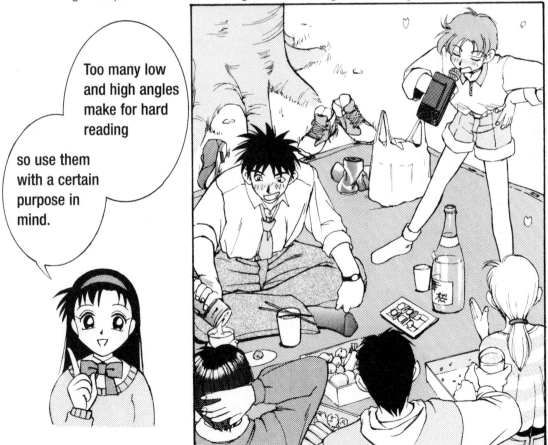

This high angle composition accents the positions and relationships of multiple characters which can be easily expressed and understood by the reader.

How to Draw One-Point Perspective

A drawing composed in perspective with one vanishing point.

Drawing this is relatively easy and often used in manga.

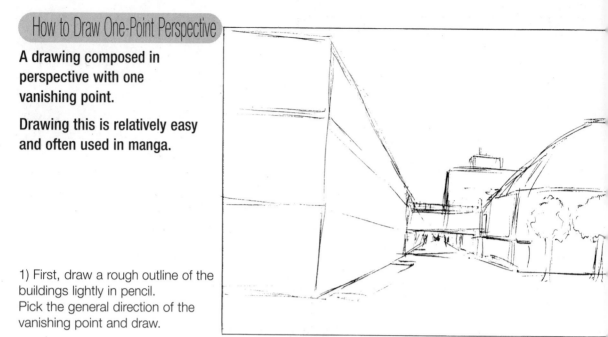

1) First, draw a rough outline of the buildings lightly in pencil.
Pick the general direction of the vanishing point and draw.

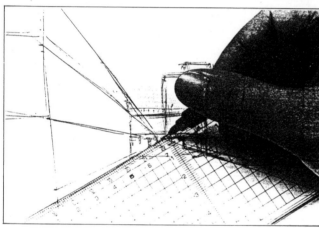

2) Next, set the vanishing point and draw radiating lines of perspective from there. Some people like to draw these lines with a colored pencil.

3) With the lines as a yardstick, outline the details of the buildings. Pay attention to details like the windows. When a character is in frame, pay mind to the character's line of sight.

Draw horizontal and vertical lines at perpendicular angles when the building is facing forward.

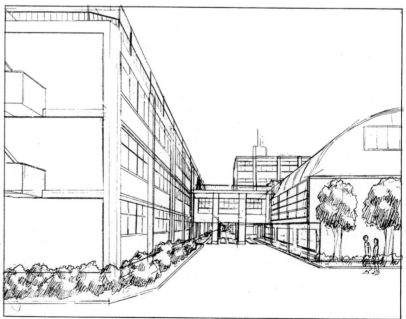

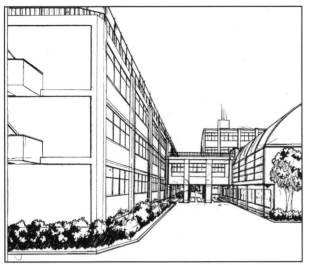

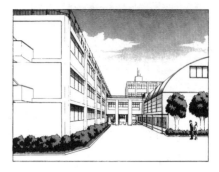

5) After inking, add in white filling and then tones (see page 34 for reference).

4) When the pencil rough is finished, do the inking.

To divide perpendicular lines in half in perspective, the point of intersection of the diagonal lines marks the center. Draw diagonal lines through the center.

The angle changes the size of the height and width.

vanishing point

The areas can be further divided giving more details by using the earlier method.

one fourth marker

one half marker

center of the figure

vanishing point

To divide into fourths, mark another center point and draw diagonal lines through it.

To draw windows and brick walls correctly, draw diagonal guidelines.

The height of the stick figure acts as a guideline.

In scenes where there is no character, adding in a simple stick figure acts as a yardstick for doors and windows.

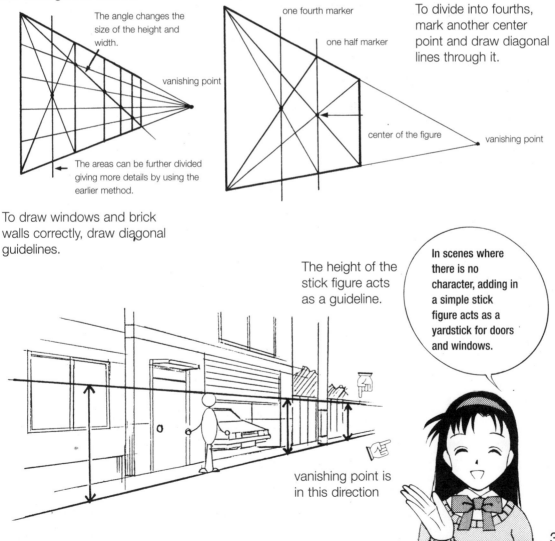

vanishing point is in this direction

How to Draw Two-Point Perspective

A drawing composed in perspective with two vanishing points.
This drawing gives more depth than one done using one-point perspective.

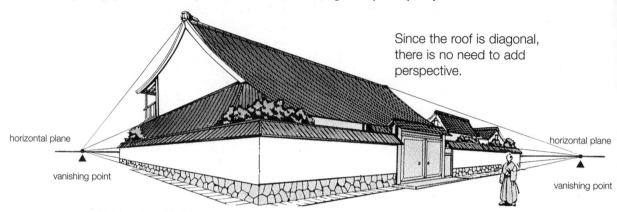

Since the roof is diagonal, there is no need to add perspective.

horizontal plane

horizontal plane

vanishing point

vanishing point

As a point of caution, make sure that both vanishing points line up on the same horizontal plane. Also use contour lines in creating perspective with the vanishing points since curved angles and corners can be tricky.

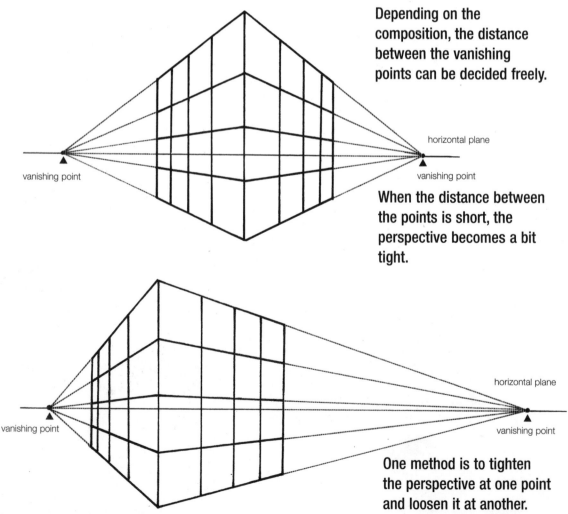

Depending on the composition, the distance between the vanishing points can be decided freely.

horizontal plane

vanishing point

vanishing point

When the distance between the points is short, the perspective becomes a bit tight.

horizontal plane

vanishing point

vanishing point

One method is to tighten the perspective at one point and loosen it at another.

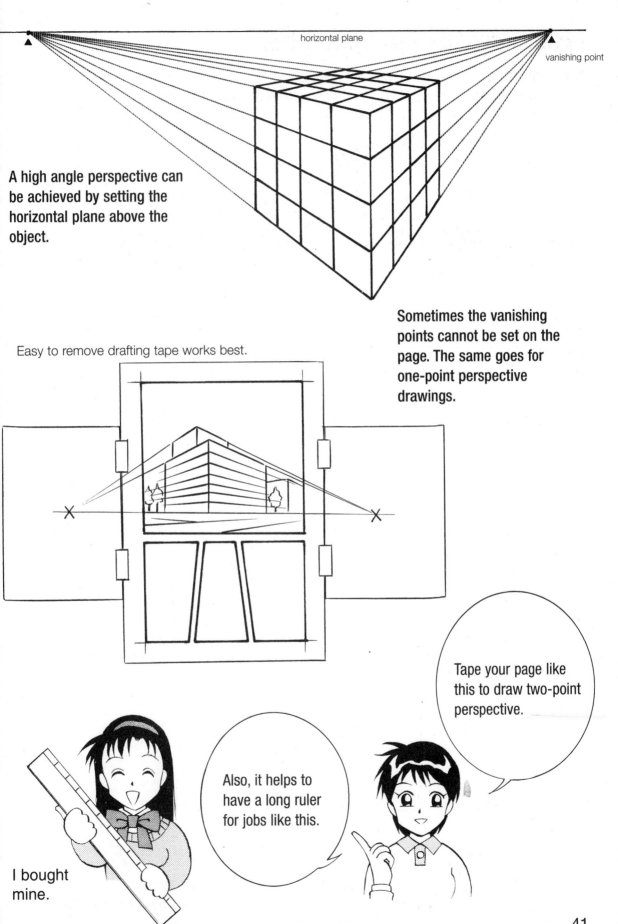

horizontal plane

vanishing point

A high angle perspective can be achieved by setting the horizontal plane above the object.

Sometimes the vanishing points cannot be set on the page. The same goes for one-point perspective drawings.

Easy to remove drafting tape works best.

Tape your page like this to draw two-point perspective.

Also, it helps to have a long ruler for jobs like this.

I bought mine.

How to Draw Three-Point Perspective

Choose two vanishing points on the same horizontal plane.

A drawing composed in perspective with three vanishing points.
The actual buildings that we see in town in every day are examples of three-point perspective; however, as these are difficult and time consuming to draw, they are not often found in manga. When used in low and high angle pictures, a sense of depth in the perspective is brought out.

The latticework gets smaller and smaller as it moves towards the vanishing points.
While most manga is drawn from instincts, it is a good idea to consult a proper book on perspective for drawings like this.

vanishing point

horizontal plane

vanishing point

vanishing point

High Angle View

Choosing vanishing points below, a high angle view can be achieved.

Draw the horizontal plane somewhere above the picture.

Low Angle View

Choosing three vanishing points above, a low angle view can be achieved.

Draw the horizontal plane somewhere below the picture.

As a general rule, the third vanishing point will be further than the other two. Sometimes your longest ruler may not be enough. In this case, you can draw guidelines with your instincts.

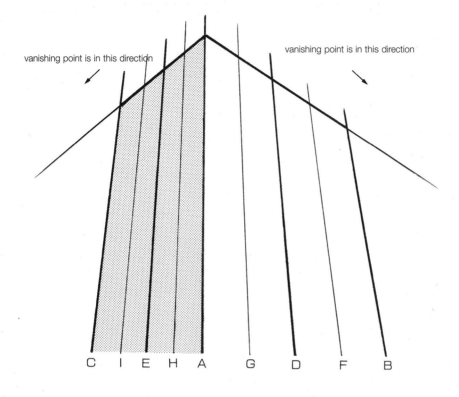

vanishing point is in this direction

vanishing point is in this direction

C I E H A G D F B

1) First draw line A which is at the curve of the building.
2) Then, outline the building with lines B and C.
3) Next, divide the area between lines A and B drawing line D. Do the same on the other side drawing line E.
4) Finally, draw line F between B and D. Do the same with the rest drawing lines G, H and I.

This is how you divide and draw guidelines.

Since the drawing is a manga afterall, perspective doesn't have to be perfect but make sure it doesn't look strange at first glance.

Deformed Perspective

**The following examples are classical deformed perspective picture found in manga.
While they are not used too often, they are impressive when used for setting a scene.**

Deformed Low Angle

Deformed High Angle

The vanishing point
should be placed
somewhere in the
center for these extreme
low and high angle
shots.

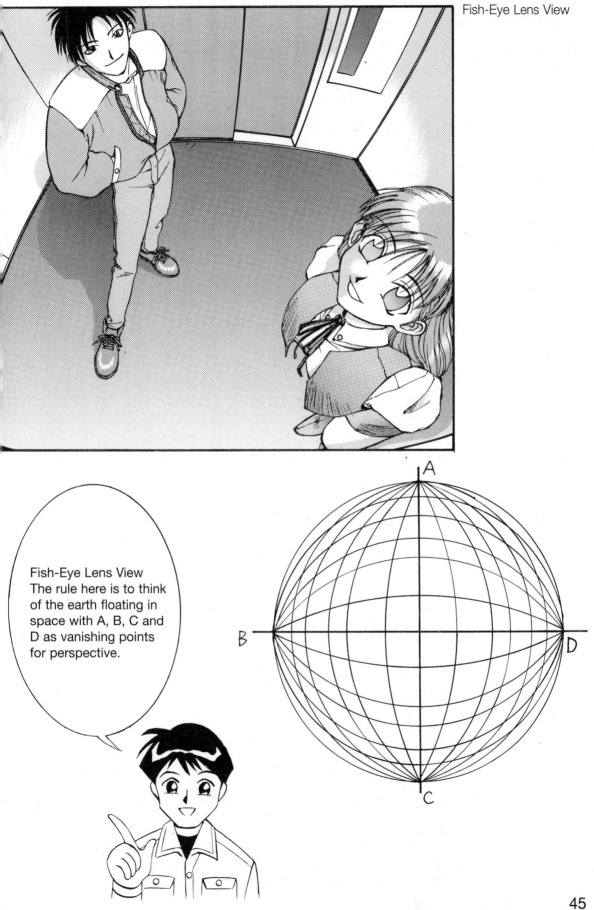

Fish-Eye Lens View
The rule here is to think
of the earth floating in
space with A, B, C and
D as vanishing points
for perspective.

A

B

D

C

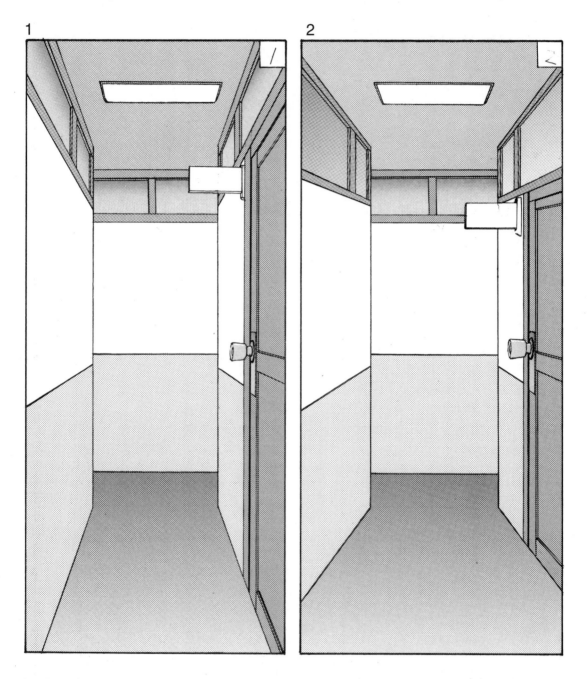

Look at the two illustrations above. These are of the same picture drawn using
two different techniques.
Drawing 1 makes use of one-point perspective while drawing 2 uses three different
vanishing points which is known as trick one-point perspective or 'damashi itten' or
'mayakashi itten' in Japanese.

How to Draw Trick One-Point Perspective

Drawing 1 uses one-point perspective with A as the vanishing point set on a horizontal plane.

Drawing 2 uses trick one-point perspective.
In this case, two additional perpendicular vanishing points C and D are added to B - the main vanishing point.

As long as C and D are perpendicular and don't seem out of place then everything is all right.

When placing a character in the scene, draw in perspective from a point near the knees towards the floor. Then draw in perspective from point B.

The same goes for placing objects. Divide the placement of the three vanishing points well, and as long as it doesn't look strange then there should be no problems.

This technique is used for placing characters in a small space or making a small space look bigger. Sometimes the perspective can get a little out of whack when laying out furniture so be careful.

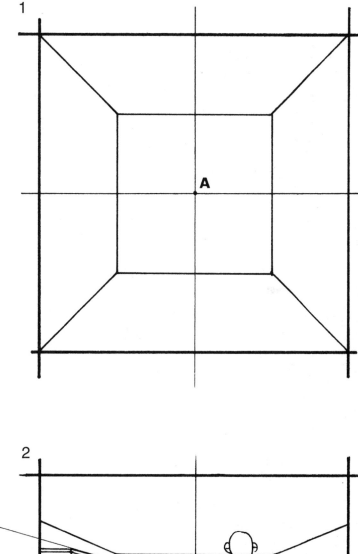

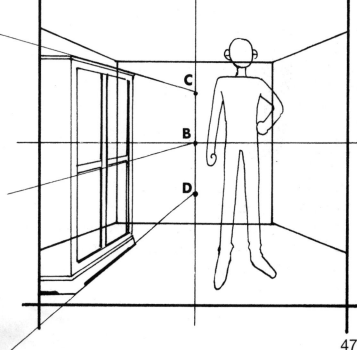

Drawing Backgrounds by Tracing Photographs

Tracing photographs is a method for doing backgrounds for those who find drawing in perspective difficult or for intricate exteriors.

1) Prepare some photographs as materials.

2) Photocopy to the desired size. Expand or reduce the size of the photo using a copy machine.

3) Tape the photocopy on the back of the page. Tape the photocopy with drafting tape to fill the frame as desired.

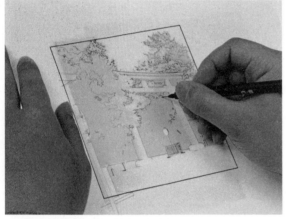

4) Outline using a tracing table.
Turn the tracing table light on and trace around the lines of the copied photo. Tracing every detail is not necessary. Choose which lines you want to include.

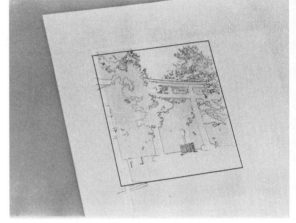

5) Turn the light off and view the drawing.
After finishing the outline, turn the tracing table light off and check the drawing for unconnected lines. Turn the light off periodically while drawing to get a feel for the finished work.

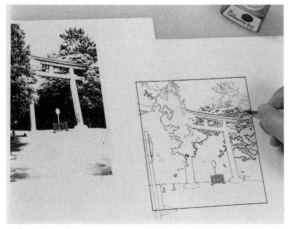

6) Ink over the outline with a pen.
Add in ink with a pen and finish the work.

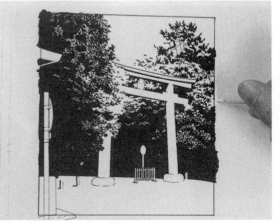

7) Fix problem areas with white.
After inking with black, put the finishing touches on with white.

Finished Work
Add in tones and finish the work.

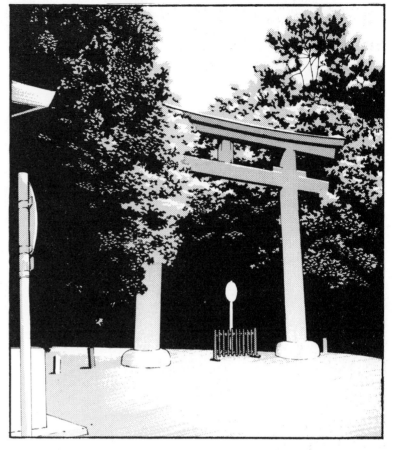

Other Uses of Tracing

For those that find drawing faces
at one angle difficult, try
reversing the angle using
tracing paper.

When adding tones sometimes it
is hard to see the lines of the
drawing and/or cut the tones.
Using a tracing table helps.

If you don't have a tracing table...

A table helps when
doing difficult to cut
coarse tones.

This technique is a little tiring but
works. On a sunny day, take
your pages to the window and
start tracing.

try using a glass table
placing a desk lamp under
the table.

Drawing Circles in Perspective

Circles, when viewed from a diagonal angles, look like ovals. To draw a circle in one-point perspective, the circle facing forward should remain a circle and the other circle should be drawn as an oval.

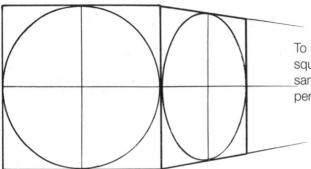

To draw an oval, it should fit into the square giving it perspective. The same goes for two and three-point perspective.

Ovals can be drawn freehand; however, for those who want to be precise, use an oval ruler or draftsman's curve ruler or freehand ruler.

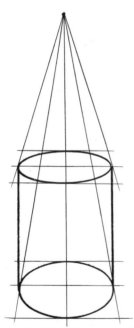

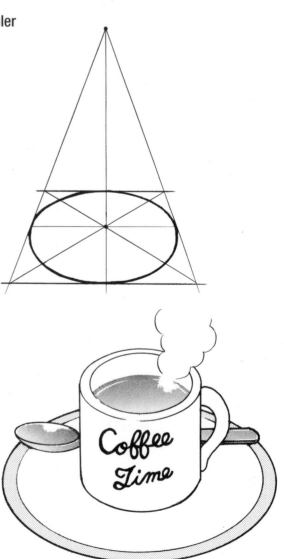

To draw circular pillars in perspective, the ovals on the top and bottom will be of different sizes.

As small circular objects used in insert shots like this are drawn with no vanishing point, the size of the top and bottom circles are the same.

Coffee Time

Chapter 2
Tone Techniques

Tone Types

Letra 61
There are several types depending on the size of the dots and gaps.

Letra 738
There are several types depending on the width of the white and black areas.

The most widely used tones are: net or seine 'amitoon' in Japanese and gradation of the 'group tone' variety.

Amitoon #61 - 'rokujuichi ban' in Japanese - is a basic manga tone used widely in shadows and the like.

The tones printed on pages 52 and 53 are actual tone pages reduced in size to 83%.

Since commercial manga magazines are reduced and then printed (usually at rate of 1/1.2), the look of a number 61 tone will change. The tones on pages 52 and 53 have been reduced and printed at the same rate. Please compare them to your tones.

While the tones may have the same number (i.e. 61), they are slightly different depending on the supplier. The correct measure of dots and gaps and sizes are listed in the tone catalogues. Take for example Letra Screen Tone 61. The catalogue reads 55/10%. The number on the left is the number of dots per inch (2.54 cm for our European readers) in this case 55. The number on the right is the percentage of a fixed area that the dots exist in.
The higher the number on the left, the closer the dots are. The higher the percentage, the darker the page. For IC Screens a 55/10% tone would be S-51.

Other Widely Used Tones

Lined - 'sen' in Japanese - Tone

Grain- 'suname' in Japanese - Tone

These pattern - 'gara' in Japanese - tones are widely used.

ICS-171

Letra 327
Several varieties as well as gradation patterns are available depending on the details of the grain and coarseness.

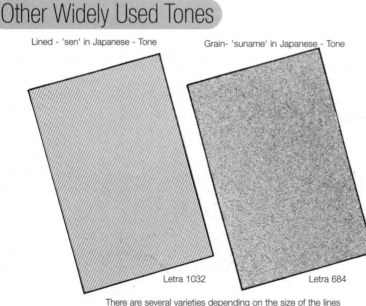

Letra 1032

Letra 684

There are several varieties depending on the size of the lines and space between them.

Pen drawn visual direction effects and techniques have also been made available as tone patterns.

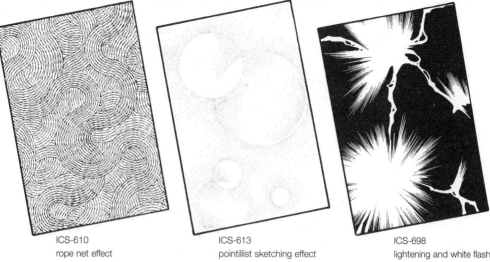

ICS-610
rope net effect

ICS-613
pointillist sketching effect

ICS-698
lightening and white flash
combination effect

There are also original visual direction effect tones.

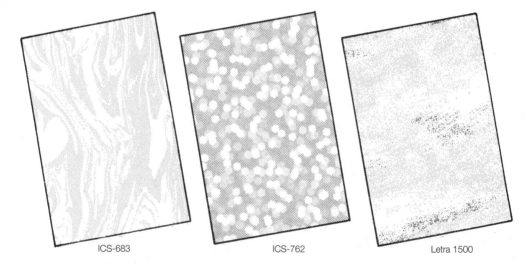

ICS-683

ICS-762

Letra 1500

There are also white tones. These being white dot or striped versions which yield a hazed effect when placed on top of drawings. (The tones shown here make use of black with white placed on top.)

Letra 270

ICS-22

ICWS-242

ICS-408

This is just a brief description of the many tones available. There are especially a large variety of pattern tones used for clothing and the like available. As new types of tones are continually appearing on the market, it makes going to your local art supply shop fun.

White tones are used to make scenery in a distance look hazy or for flashback scenes. White tones are available in net, lined as well as gradation and grain.

Tone Tools

These are the tools you need for using tones.

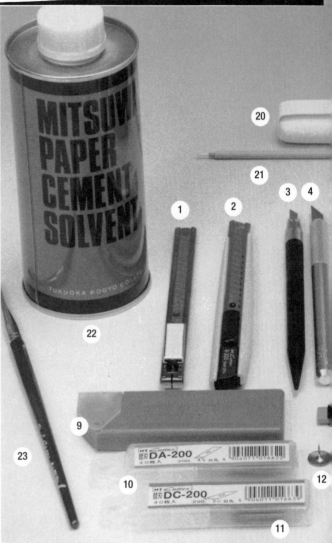

1), 2) Standard cutters can be used not only for cutting tones but also a variety of effects can be created by scrapping the underside of the tones.

3), 4) Design cutters are used by some people for cutting tones. They are easy to use for tone flashes.

5) ,6), 7), 8) Tone rubber for rubbing and attaching tones. While commonly called a 'toonbera' in Japanese, suppliers have different names for it. Buy the one that works best for you.

9) Standard cutter replacement blades

10), 11) Design cutter replacement blades. Use a blade that works for you. 10 - This 45° blade is used by most. 11 - 30° blade.

Pencil type sand eraser. Low force erasing gives a gradation effect.

13), 14) Sand erasers give a gradation effect from varied tone rubbing.

15) Plastic eraser used for cleaning up excess glue on pages. Be careful using this with some tones not to reduce net patterns.

16) Blue colored pencil. Use for rough drawing on tones but if you mark to heavily, it will show up at print time.

17) Feather duster. Use to clean up the excess from cutting into tones. Some people use handheld vacuum cleaners.

18) Metal edged clear ruler. Use for tone flashes.

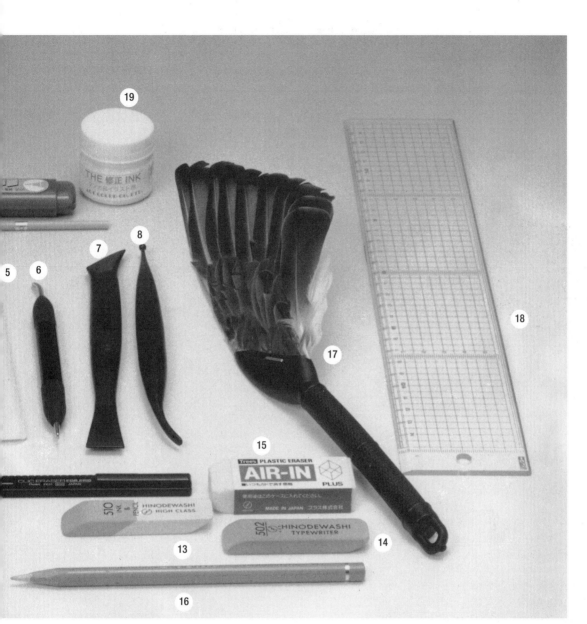

19), 20), 21) White ink, white-out, brush for applying white. Use for cleaning up edges and etching tones. Thin brushes are easier to use.

22), 23) Paper cement solvent and artificial hair brush. Use for taking off hard-to-remove tones. The brush is built to last.

24) Thumbtacks. Use for setting center points for tone flashes.

For taking off hard-to-remove tones use an artificial hair brush to apply some solvent to the edge of the tone. Grab the unattached area applying more solvent while slowly removing the tone.

How to Apply Tones

Enough talking. Let's do some tones.

1) Clean the page and work area.
Not enough can be said about cleanliness. Dirt and dust from glue on the back of tones can ruin tones.

2) Place over the page and make a rough cut
To prevent dirt from getting on unused portions of the back of the tone sheet, it's best to cut tones this way.

3) Temporarily attach the tone to the page.
Pull of the backside of the tone sheet placing it on the page. Watch out for air bubbles. Apply with light force as adjustments may need to be made. Place the backside of the tone on top and using the tone rubber rub·away.

4) Cut the tone along the lines of the drawing. Cut with care preventing gaps inside and outside the lines.

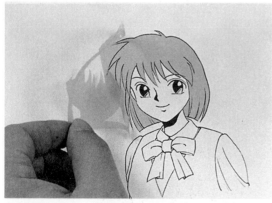

5) Remove the leftover areas.
Slowly and carefully remove the tone. Remember to erase the tone glue if not reapplying tones.

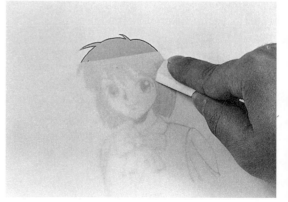

6) Place the backside of the tone on top and attach firmly.
After the final cut, place the backside on the top of the tone and rub with the tone rubber. Apply enough force to firmly keep the tone in place.

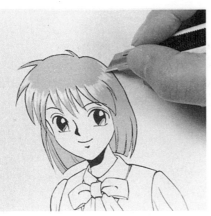

7) Add highlights to the hair.
Cutting away points with a cutter gives a highlight effect. This makes a mess which makes pages dirty so dust away the grime.

Rubbing the tones without a buffer page twists the tones out of whack so don't do it.

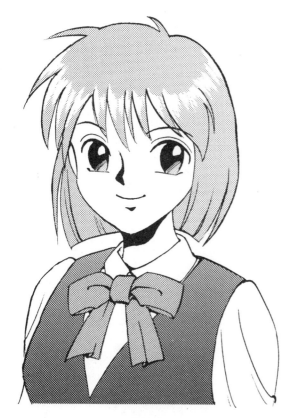

finished work (full scale)

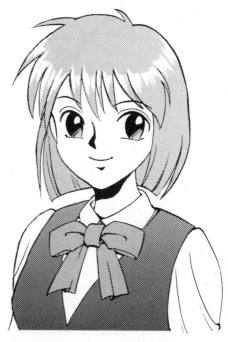

finished work (reduced to 83% and printed)

How to Etch Tones

Before etching ascertain the stitching of the tone. For those who want to learn high-end techniques this section is for you.

A standard tone sheet placed at 0°

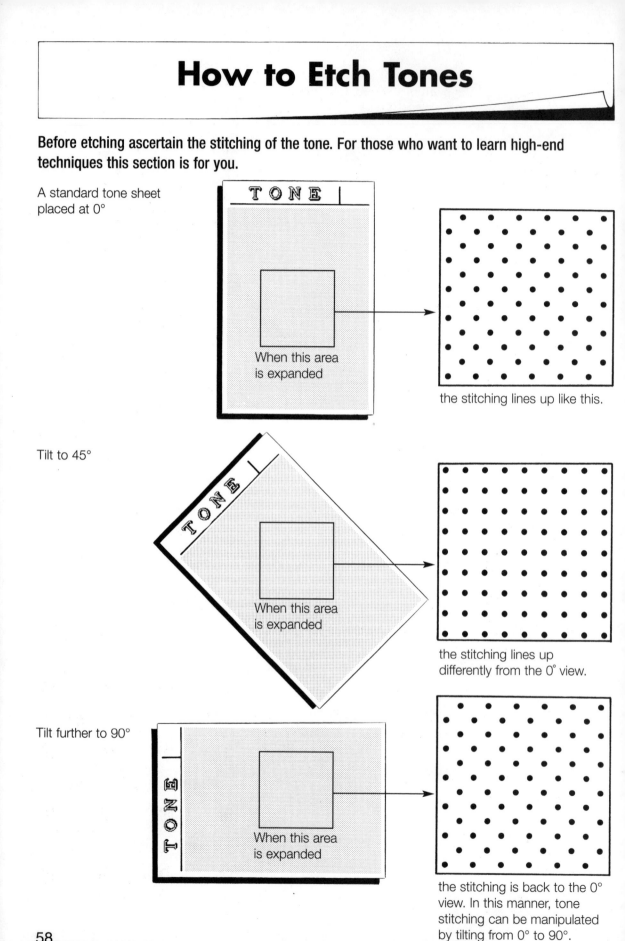

When this area is expanded

the stitching lines up like this.

Tilt to 45°

When this area is expanded

the stitching lines up differently from the 0° view.

Tilt further to 90°

When this area is expanded

the stitching is back to the 0° view. In this manner, tone stitching can be manipulated by tilting from 0° to 90°.

The key is to find to 0° point of the dots and the top of your page. It should look like this.

The reason is that it is highly important for etching and layering.

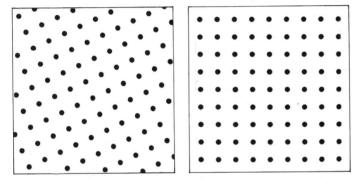

Here the tones have been pasted out of sync. Depending on the manga artist, some people work from the 0° position and some artists just paste away not worrying. Also, for gradation tones, some like to tilt to one side or another considering the direction of the light.

Find the NUMBER FIVE on the dice.

In the 0° position, the dots line up like the number five on a dice. X or in this case 'five' marks the spot.

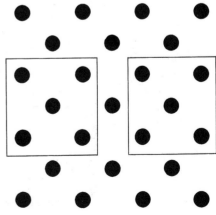

These next two have been placed in the zero position and etched at different angles.

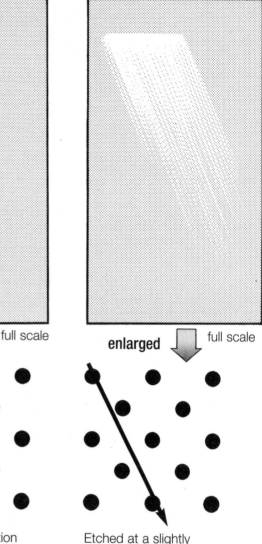

What do you think?
Focus your eyes and look closely.
Example B looks to have been etching more cleanly than A.

enlarged full scale enlarged full scale

In short, etching in the same direction as the dots doesn't look clean and makes for holes so it is important to etch at a slightly different angle from chosen degree of dots.

Etched in the direction of the dots.
This makes for holes in the etching.

Etched at a slightly different direction of the dots.
The dots are slowly etched out one by one.

What is meant by a 'slightly different angle' is somewhere between 0°, 45° and 90° - ideally 22.5° and 67.5°.

0° 22.5° 45°

67.5(22.5°)

90°

22.5° is the best range and makes for clean, beautiful etching. Or somewhere around there anyway.

60

Explaining the 360° view again...

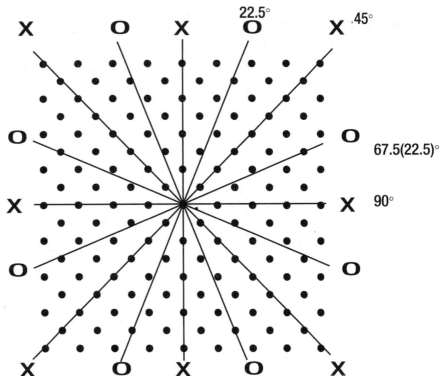

The O's mark the easy to etch lines while the X's mark the difficult to etch lines.

For gradation tones, after ascertaining the direction of the dots, pick the etching angle.

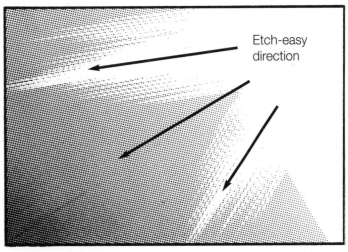

Etch-easy direction

full scale

For etching horizontally and vertically etching within the frames, first tilt the tone to a 22.5° angle and then etch.

full scale

Freehand Etching Using a Cutter

First choose the section of the blade for etching.

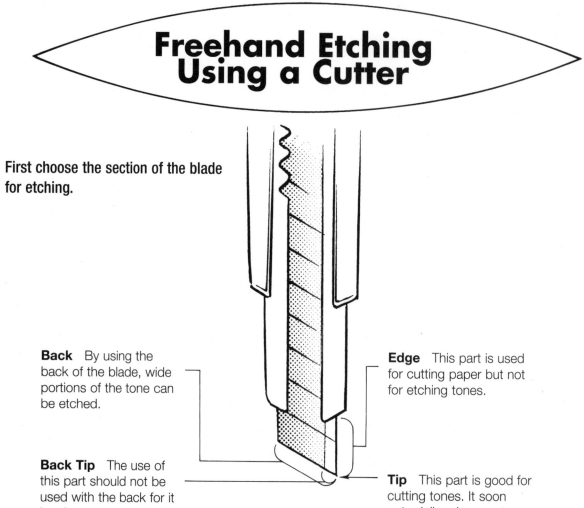

Back By using the back of the blade, wide portions of the tone can be etched.

Back Tip The use of this part should not be used with the back for it has its own uses. It is an important section with a variety of uses.

Edge This part is used for cutting paper but not for etching tones.

Tip This part is good for cutting tones. It soon gets dull so be sure to change blades often.

Two Points of Caution

The only way to get good at etching is to start etching so let's get to it.

SCRAPE, SCRAPE

1. Firmly attach the areas of the tone for etching

It is not a good idea to etch with tones temporarily set into place. Temporary means temporary (i.e. easy to remove and replace). While tones don't have to be as firmly set as in the finished work, tones set too lightly will cause the cutter to get caught up in concave and convex portion of the tone.

2. The method of holding the cutter (as shown in the drawing) is for reference only.

Just like people hold pens differently, people hold cutters differently. The example shown here is just that - an example.

Tip Cutting and Etching

This is the fundamental way of cutting in a straight line using the cutter tip.

The illustration is only for your reference. This exact angle does not have to be followed. Also, when cutting with the tip, if you use the entire tip it will get caught in the tone and won't cut. You need to find a delicate balance in the angle that you slant the cutter.

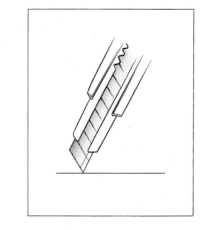

a. Etching Inward

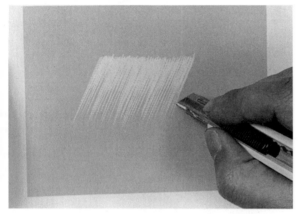

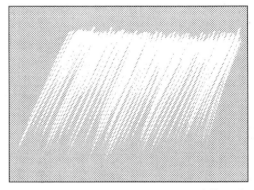

full scale

With the tip of the cutter, etch toward yourself.
At first put a little tension on the blade following through and releasing tension as you etch. Recall that the same method was used when drawing emphasis and flash lines.
Try etching at a 22.5° angle in regards to the dots of the tone.

b. Etching Outward

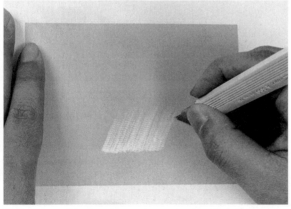

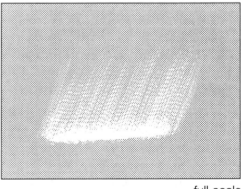

full scale

This time with the tip of the cutter etch away from yourself.
While the lines will be shorter than the inward etching lines, the blade is much easier to delicately control and thinner lines can be etched.

c. Long Etching

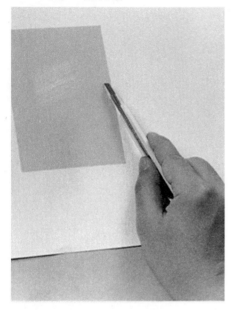

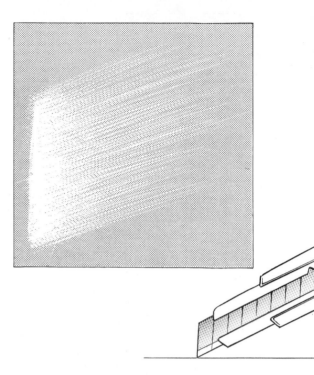

Hold the cutter as shown above
and etch away from yourself.
Without breaking your wrist and
with your elbow as the fulcrum,
move your arm and etch. Long
lines can be etched this way.

d. Double Etching With the Tipa

Gradations can be drawn by double etching
with the tip at 22.5° and 67.5° angles.

CAUTION: Try not to draw the lines of the two
different angles the same length. As for width,
keep both of the sets of lines thin.

22.5°

67.5°

Draw one of the sets
of lines longer than
the other.

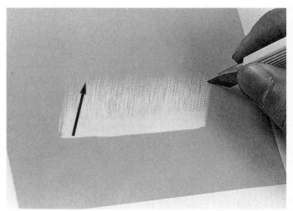

1) First etch at 22.5°

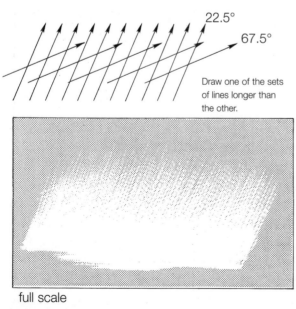

full scale

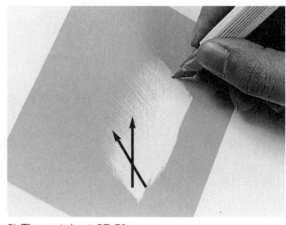

2) Then etch at 67.5°

Etching with the Back of the Tip

Etch using the back of the tip of the cutter. Change the angle towards the back of the cutter and then etch.

This way wider etching can be done than with the tip etching method.
While the drawing on the bottom left was etched in a straight line, depending on delicate changes in blade tension, speed and angle, a variety can be expressed.
While this is quite a difficult, high level etching technique, give it your best shot.
Also, you can etch at various angles with this method and do not have to worry about the 22.5° rule.

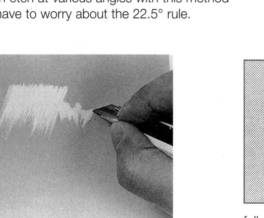

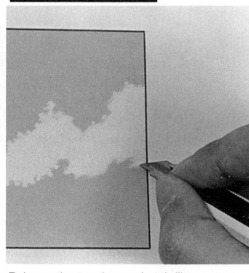

full scale

Etching Cloud Outlines

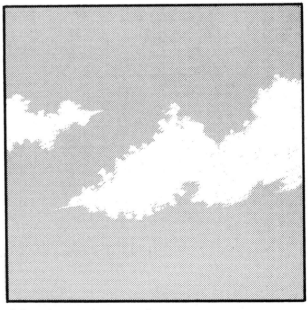

Release the tension and etch like you are creating small spheres with a soft, shading effect.

full scale

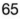

Etching Flames

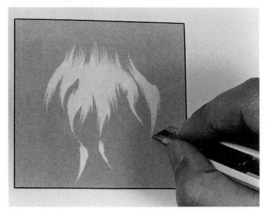

The key is to etch with powerful, determined strokes.

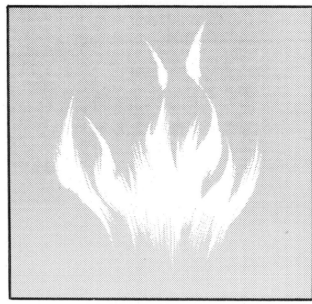

full scale

Etching with the Back of the Blade

The majority of the blade will make contact with the tone.

With this technique, short, dim, blurred gradations like that of a mellow light can be expressed or unneeded parts of the tone can be made white. At first put a little tension on the blade following through and releasing tension as you etch. Be careful not to etch with too much speed as the mellow effect will be lost.

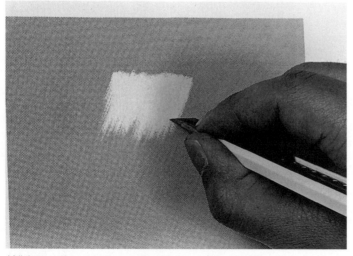

Wide section can be etched in one fail swoop.

full scale

Tap Etching with the Back Tip

**Tap using the back tip of the blade.
While this technique of etching dots one by one takes time and patience, these finishing touches yield a particular atmosphere.**

Etch the dots one by one in a pointillism style. Modulate going for a gradation effect.

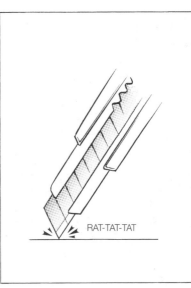

RAT-TAT-TAT

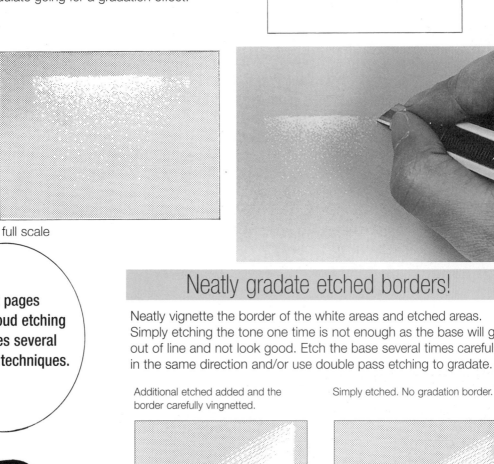

full scale

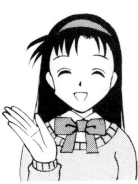

The next pages cover cloud etching and mixes several of these techniques.

Neatly gradate etched borders!

Neatly vignette the border of the white areas and etched areas. Simply etching the tone one time is not enough as the base will get out of line and not look good. Etch the base several times carefully in the same direction and/or use double pass etching to gradate.

Additional etched added and the border carefully vingnetted.

Simply etched. No gradation border.

How to Etch
Clouds

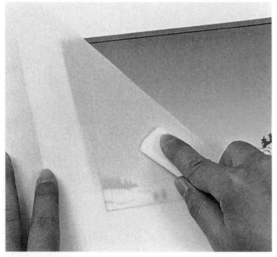

1) Attach the tone

Temporarily attach the tone more than covering the work area. If you are using a cutter, attach the tone more firmly. If you don't, the cutter will be get in the tone and won't cut well.

2) Mark off the area

With a blue pencil sketch a cloud. If you are worried about the line showing up, use a pencil and remove later with an eraser.

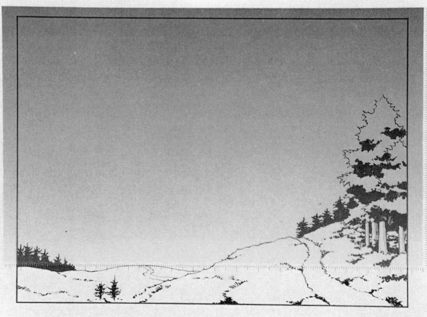

Bird's eye view of the attached tone

3) Etch with a cutter

When etching clouds, mix it up using various blade etching techniques.

a. Irregularly etch the outline predominantly using the back tip of the cutter.

b. Gradate sections using the tip of the cutter.

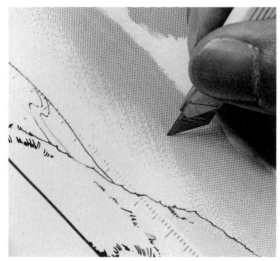

c. Carefully gradate areas near the horizon, using the tip of the cutter.

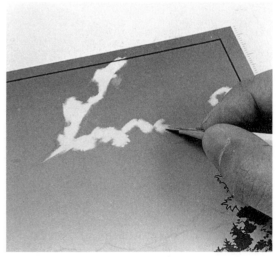

d. Large white areas can be cut out later or etched.

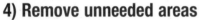

More on Etching Clouds

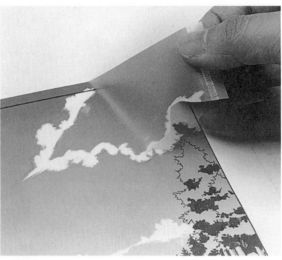

4) Remove unneeded areas

As the tone has been temporarily attached rather firmly, be careful when removing.

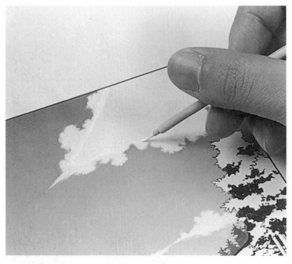

5) Touch up with white

The outline of the removed area and holes made from the tip of the cutter are where dirt builds up, so be sure to fill in with white. Go over it once with an eraser and then touch up with white.

In addition to this, various types of cloud can be expressed using different tone etching techniques.

6) Finished Work

Add the tone to the other areas finishing the work.

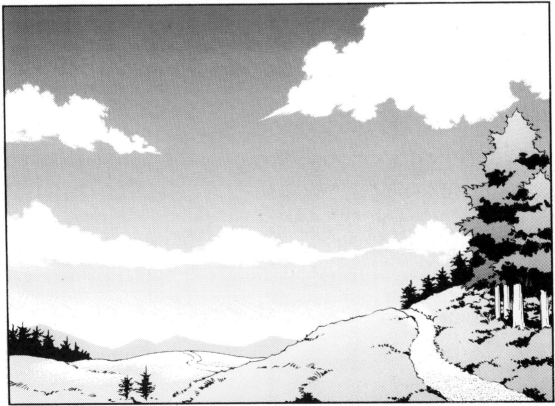

reduced to 83% and printed

Etching With a Ruler

Try using a ruler when etching tone flashes.

1) Mark a center point and draw two circles on the tone with a blue pencil or pencil. The inner circle will be your starting point for etching. Now stick a thumbtack in the center point.

Cutter Blade Angles

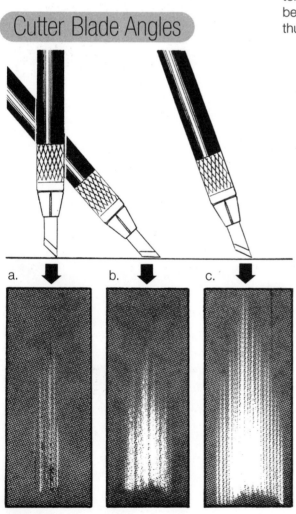

a. b. c.

full scale

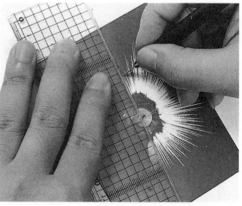

2) Etch using a design cutter along the edge of the ruler. It is easier to start in the middle etching outward. Because of the size of the flash and thumbtack, a normal sized acrylic ruler is used here.

a. If the cutter is too upright, it can't cut and scratches the tone.

b. If the cutter is too prone, it etches too widely.

c. Find a delicate, balance in the angle of the blade for etching. Made the first etch with a prone angle getting a feel for the tone. Then little by little change the angle of the blade upright and etch away.

Notes of Caution

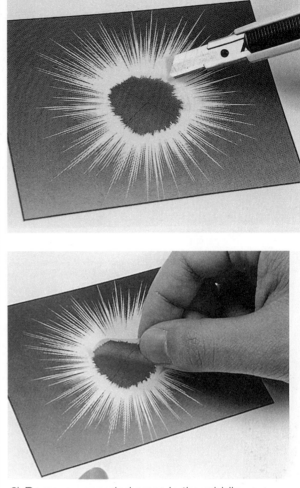

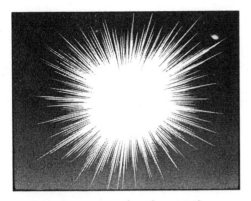

a. Dots located at 0°, 45° and 90° angles are difficult to etch. Carefully do your best.

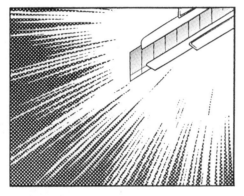

b. Etch left over areas with a standard cutter.

3) Remove unneeded areas in the middle.

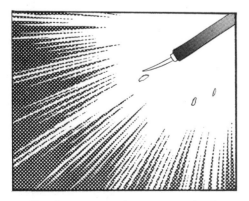

c. Touch up areas that were etched too deeply with white.

CAUTION

Design cutters get dull fast, making them hard to cut. Change your blade as soon as it gets hard to cut.

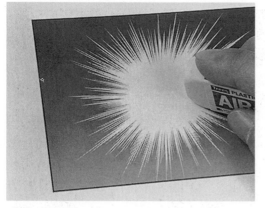

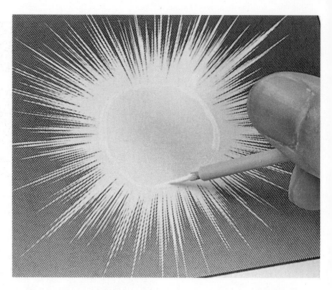

4) Go over it with an eraser once. After removing the tone glue, fill in the removed area and tack hole with white.

5) Finished Work (full scale)

reduced to 83% and printed

Lightening Flashes

The lightening flash technique described on page 25 can also be done with tones.

reduced to 83% and printed

 CAUTION **When adding white on top of tones**

3) Now the white can be added neatly.

2) Use an eraser to remove the oils on the tone.

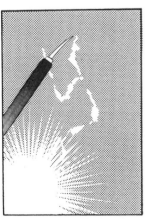

1) Without using an eraser the oils on the tone cause the white to run.

Etching Inward

If you become accustomed to etching outward, try etching in the other direction with a design cutter.
Long flashes can be etched. When making long flashes, use a ruler with metal edge.

Various forms of tone flashes appear in manga.

They are often used when the character has a realization.
If you become accustomed to tone flashes, they can be done faster and easier than all black flashes.
©Yagami Yuu/Media Works/Dengeki Comics Gao! "ERUFU WO KARU MONOTACHI"

Tone flashes made good dialogue balloons.
©Yagami Yuu/Media Works/Dengeki Comics Gao! "ERUFU WO KARU MONOTACHI"

Balloon flash tone
Flashes were etched twice - from interior and exterior.
© Yagami Yuu/Media Works/Dengeki Comics Gao! "ERUFU WO KARU MONOTACHI"

They can be used for other visual direction effects (see page 94).

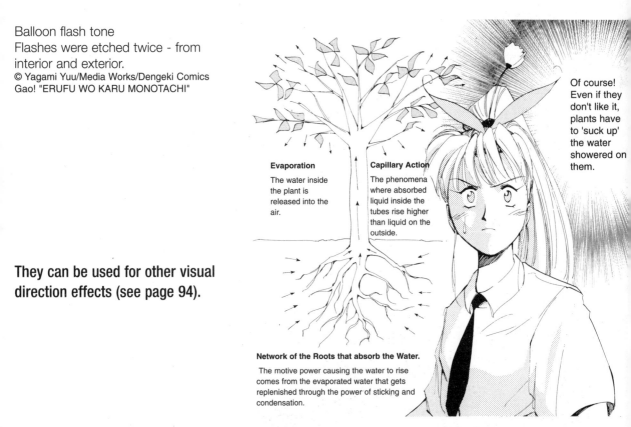

Of course! Even if they don't like it, plants have to 'suck up' the water showered on them.

Evaporation

The water inside the plant is released into the air.

Capillary Action

The phenomena where absorbed liquid inside the tubes rise higher than liquid on the outside.

Network of the Roots that absorb the Water.

The motive power causing the water to rise comes from the evaporated water that gets replenished through the power of sticking and condensation.

Etching With a Sand Eraser

The page can be dimly gradated with a sand eraser.

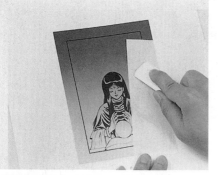

1) Attach the tone to the page.
While this is a temporary
attachment, just like with the cloud
etching, attach the tone firmly. We'll
talk about clothing tones later.

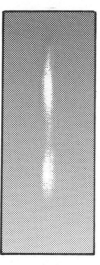

not enough force just enough force too much force

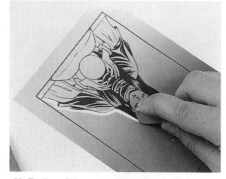

2) Rub with a sand eraser.
Etch the tone by rubbing with an
eraser.

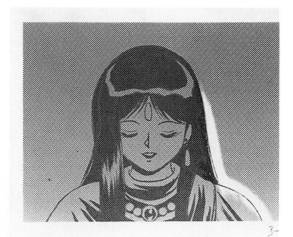

3) Modulate the angel of the eraser.
When etching an aura, modulate the angle of the eraser and the forced used as you etch.

4) Remove unneeded tone areas.
Since etching the background with a sand eraser is done, the unneeded tone areas are removed. As the tone was attached firmly, peel it back slowly and ever so carefully.

5) Remove the tone glue with an eraser.
Since the tone glue collects dirt messing up the page, go over it with an eraser removing the glue.

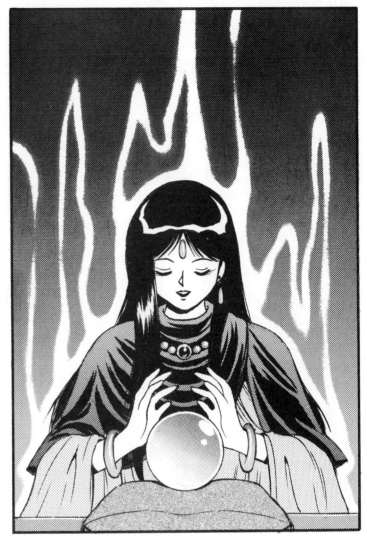

6) Finished Work
Other tones were added.

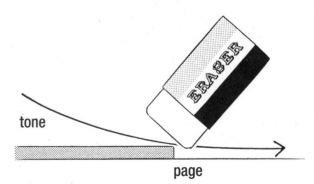

Erase towards the page from the top of the tone.

Layering Tones

One more tone technique is layering.

Look at the drawing on the right. The shadowed area of the clothing was done with a tone.

Layering methods using a coarsely dotted tone are explained on the next few pages.

When a line appears
two different tones Letra 61&73

Cut the tones along the line and paste on.

When no line appears
two different tones Letra 61&73

In this case, a white line shows up between the two tones.

When layering is used
same tones Letra 61

By layering the tones, the white line can be removed.

Adding etching with a cutter
same tones Letra 61

The only way to do something like this is to layer.

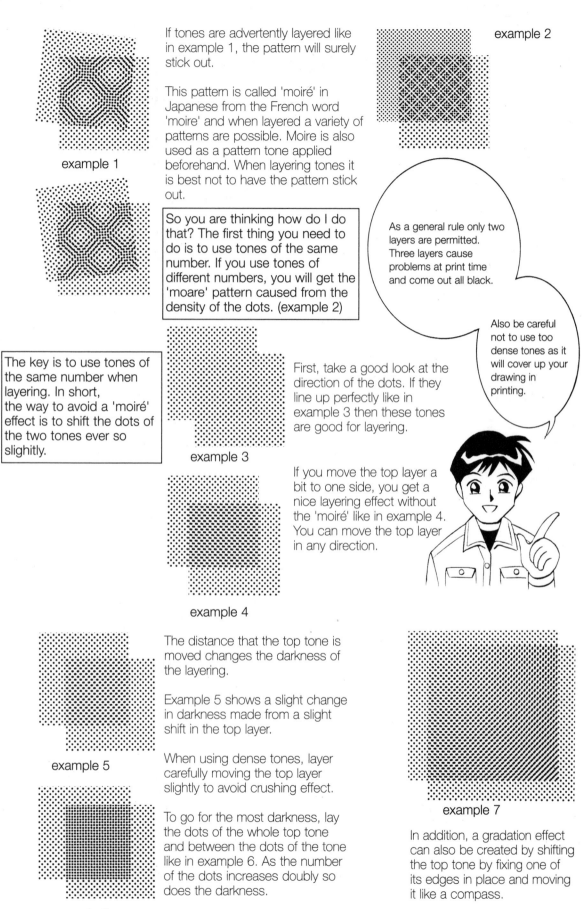

If tones are advertently layered like in example 1, the pattern will surely stick out.

This pattern is called 'moiré' in Japanese from the French word 'moire' and when layered a variety of patterns are possible. Moire is also used as a pattern tone applied beforehand. When layering tones it is best not to have the pattern stick out.

So you are thinking how do I do that? The first thing you need to do is to use tones of the same number. If you use tones of different numbers, you will get the 'moare' pattern caused from the density of the dots. (example 2)

example 1

example 2

As a general rule only two layers are permitted. Three layers cause problems at print time and come out all black.

Also be careful not to use too dense tones as it will cover up your drawing in printing.

The key is to use tones of the same number when layering. In short, the way to avoid a 'moiré' effect is to shift the dots of the two tones ever so slightly.

First, take a good look at the direction of the dots. If they line up perfectly like in example 3 then these tones are good for layering.

example 3

If you move the top layer a bit to one side, you get a nice layering effect without the 'moiré' like in example 4. You can move the top layer in any direction.

example 4

The distance that the top tone is moved changes the darkness of the layering.

Example 5 shows a slight change in darkness made from a slight shift in the top layer.

When using dense tones, layer carefully moving the top layer slightly to avoid crushing effect.

To go for the most darkness, lay the dots of the whole top tone and between the dots of the tone like in example 6. As the number of the dots increases doubly so does the darkness.

example 5

example 6

example 7

In addition, a gradation effect can also be created by shifting the top tone by fixing one of its edges in place and moving it like a compass.

How to Create Clouds at Dusk Using Layering

Clouds at dusk can be expressed using this technique.

1) Attach the tone and mark off an area

First attach the tone and mark off the area sketching a cloud.

Drawing clouds in the distance of the horizon gives the feeling of night approaching.

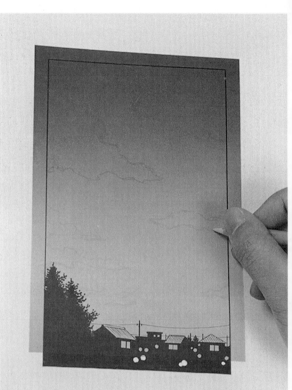

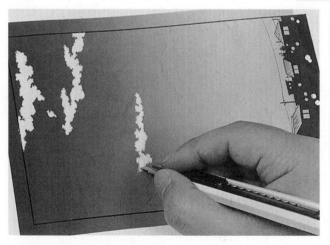

2) Etch the bottom part of the clouds

Etch these parts as light will reflect off the bottom part of the clouds in the horizon.

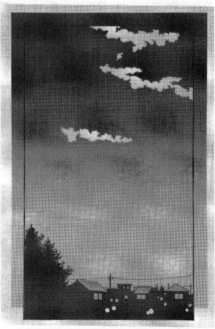

work in progress

3) Layer the tone for the top part of the clouds and etch

Layering should be used since these parts are dark.Use the same numbered tones to avoid getting moire. With gradation, avoid using in black areas.

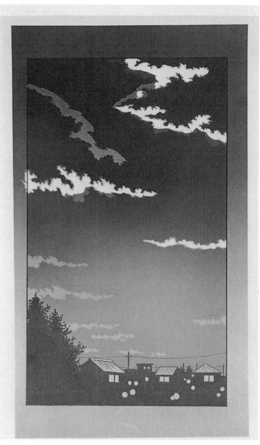

work in progress

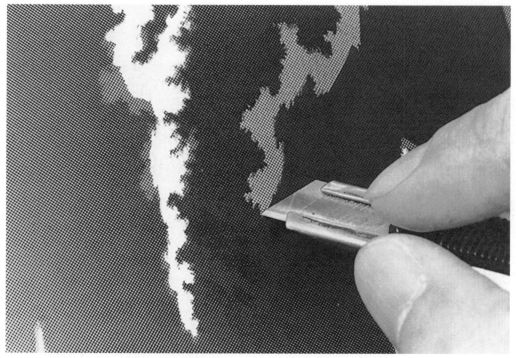

Without making a mistake, carefully etch the tone layer trying not to scratch the bottom tone layer.

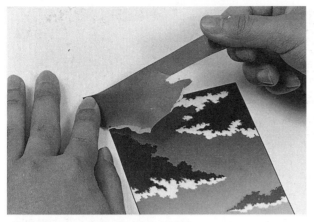

4) Remove unneeded tone area

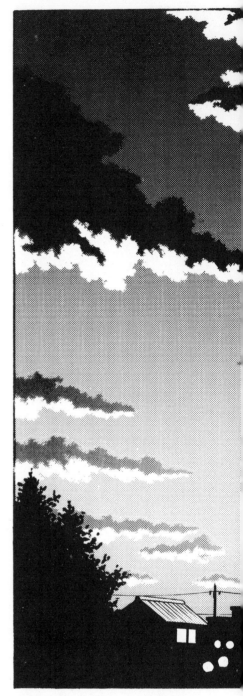

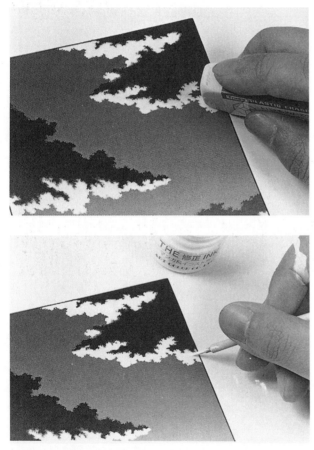

5) Go over the cut areas with an eraser and touch up with white

Dirt often gathers along the cut line creating a noticeable line that shows up in the final print. Since cut areas of the layers cannot be fixed with white, carefully use an eraser removing tone glue and dust. (Actually no matter what, a little dirt will gather.) The cut lines in the bottom white part of the cloud can be touched up with white.

6) Finished Work (full scale)

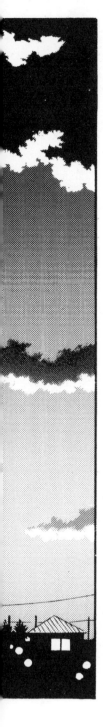

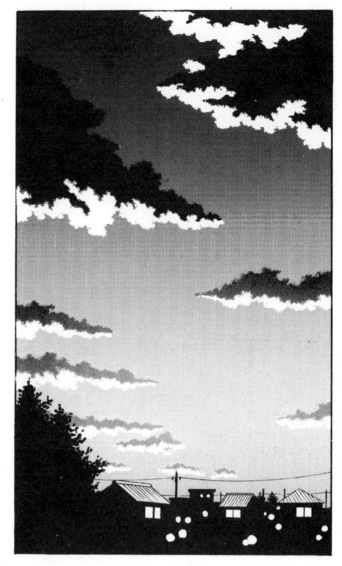

reduced to 83% and printed

CAUTION

Be careful of the direction you erase in. In the reverse direction, more dirt builds up.

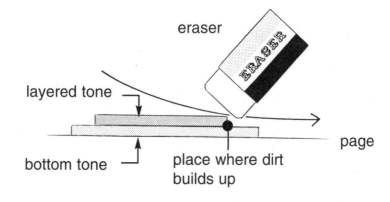

85

Using White Tones

While the majority of tone sheets are printed with black dots, lines and patterns, some are printed in white.

Use when bringing out perspective

The following tones are called 'white tones.' By applying them over other tones, the white dots cover the lines making them look disconnected giving a faded effect.

Adding a white tone to building makes it appear dim in the distance increasing the perspective.

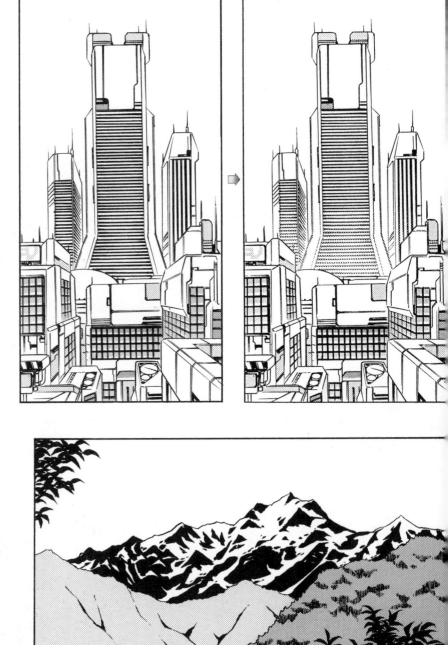

Fading off objects in the distance is a method to give a feeling of distance known as 'air perspective.'

A building drawn in black ink when covered with a white tone makes it look gradated.

Use in dream or flashback sequences

This is often when thoughts appear in the character's mind.

© Kinutani Yuu/Media Works/Dengeki Comics EX "ANGEL ARM"

When white tones are added to mountains in the distance, the amount of perspective increases.

87

Various Expressions Using Tones

Here are some examples of various expressions using tones.

Expressing Trees and Forests

Simply cutting the tones.
After drawing the outline with a blue pencil
or pencil, cut the tone.

The outlines were then rubbed with a sand eraser.

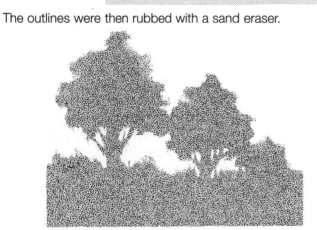

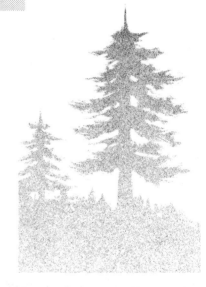

When etched in a triangular nature, the leaves and
branches look like a needle-leaf tree.

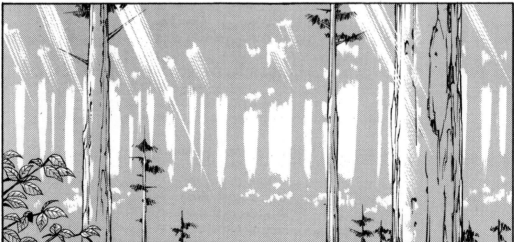

The large trees in the foreground are drawn in pen, and the trees and underbrush in the distance
are done with a tone. The key is to etch the light poking through the treetops with a ruler.

Expressing Deserts

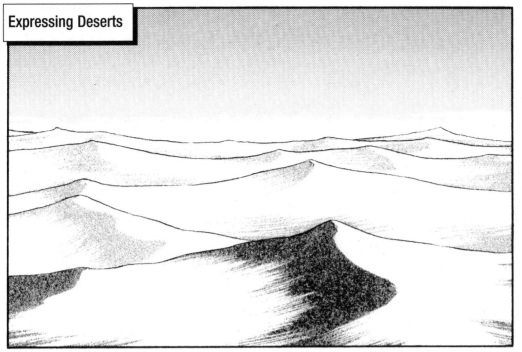

Grain tones are pasted in key points along the shadow of the sand dune. The darker tones used in the foreground with lighter tones used in the background give a feeling of perspective. Add some cutter etching at the foot of the dunes for effect.

Grain gradation tone. Paste tones to make the area near the top of the dunes look dark and the foot areas look light.

This one uses a pointillist tone. Etching and layering were used adjusting the darkness.

Using a photograph for reference, carefully etch the waves with the back tip of a cutter.

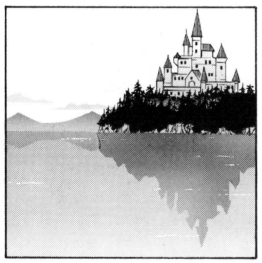

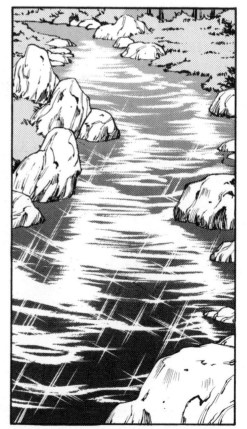

The key to lakes is to capture the reflection of the background.

The reflection makes the background look peaceful bringing out the atmosphere of the lake. When viewed from the shore, the reflection is symmetric to the castle and the size the same. Add touches of white for reflection in the water.

Adding reflected light to rivers gives them the appearance of a clear, flowing stream. These were done with a ruler finding an easy place to line up the etching.

Expressing Fire, Flames and Explosions

Use gradation tones when expressing flames and fire.

The representation changes based on the size of the flame.

fire flames candle flame

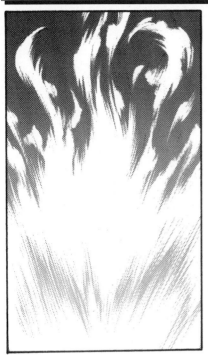

Etch with vigor in the direction of the fire. If you etch the tip of the flames in a curved manner, they become more noticeable.
Etching a bit of the center and leaving a bit brings out the dimensions.

This visual direction effect of anger is widely used.
© Kinutani Yuu/Media Works/Dengeki Comics EX "ANGEL ARM"

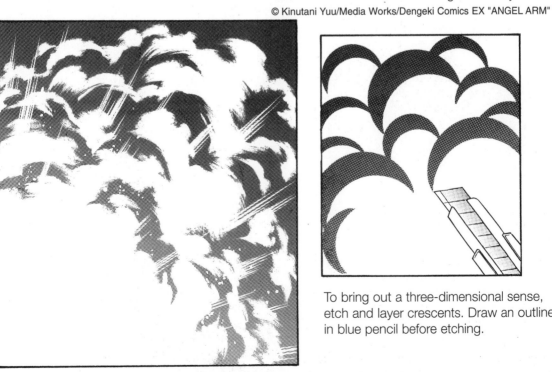

To bring out a three-dimensional sense, etch and layer crescents. Draw an outline in blue pencil before etching.

To bring out the ferocity of explosions, flashes and white are often added.

Expressing Metals and Jewelry

Using gradation tones is the key to making objects look metallic.

This example uses a gradation tone. As a general rule, the direction toward the light is darkened with the tone; however, the tone can be pasted in other directions.

Keep the direction and strength of the light as well as the ruggedness of the metal in your mind, and etch gradually while viewing the appearance of the work.

Etch the thin sections of the tone with the tip of the cutter as you see fit.

This was done with one tone with flashes etched in key points as the finishing touches.

This was done with a gradation tone with tip etching and flashes using the back tip of a cutter. Little regard was paid to the direction of the tone and etching.

Jewelry

Gems can be made to shine by making a little, white circle inside of a circularly cut gradation tone. The circle can be etched with a cutter or can be drawn with white.

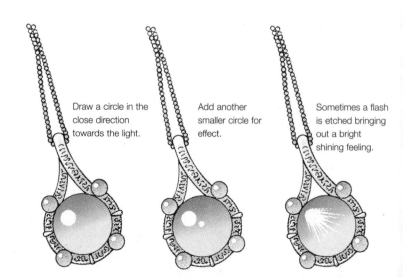

Draw a circle in the close direction towards the light.

Add another smaller circle for effect.

Sometimes a flash is etched bringing out a bright shining feeling.

Expressing Lightening

This technique involves doing the outline with a tone.

1) Temporarily attach the tone over the frame. Lightly attach it since later everything but the lightening areas will be removed.

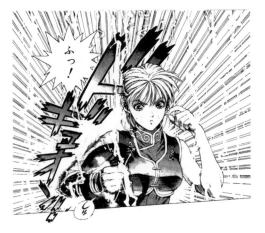

© Kinutani Yuu/Media Works/Dengeki Comics EX! "ANGEL ARM"

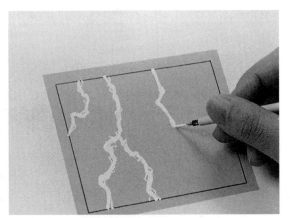

2) Along the line of the blue pencil used for outlining, draw the lightening in white.

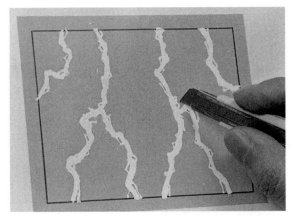

3) Cut 1mm around the lightening with a cutter.

4) Slowly remove the unneeded tone areas. Be careful not to remove the lightening areas.

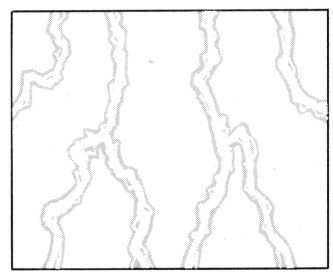

reduced to 83% and printed

Expressing Visual Direction Effects Using Tones

Take no prisoners!!

©Kinutani Yuu/Media Works/Dengeki Comics GAO!
"ERUFU WO KARU MONOTACHI"

There are a wide variety of these techniques. Here are several examples.
Tone flash effects are widely used.

This is often used for 'cool' character entrance scenes.

©Kinutani Yuu/Media Works/Dengeki Comics EX! "ANGEL ARM"

Thin tone flashes. The visual direction expresses the female character's refreshing smile.

I Think so too.

©Kinutani Yuu/Media Works/Dengeki Comics GAO! "ERUFU WO KARU MONOTACHI"

Lightening flashes. While often used to express surprise, the visual direction here expresses the character's strength and power.
©Kinutani Yuu/Enix/G Fantasy "LUCKY RAKUUN"

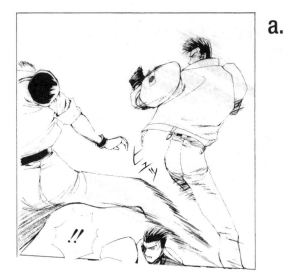

a.

©Yagami Yuu/Media Works/Dengeki Comics GAO!
"ERUFU WO KARU MONOTACHI"

d.

© Kinutani Yuu/Media Works/Dengeki Comics EX
"ANGEL ARM"

b.

© Kinutani Yuu/Media Works/Dengeki Comics EX
"ANGEL ARM"

e.

©Yagami Yuu/Media Works/Dengeki Comics GAO!
"ERUFU WO KARU MONOTACHI"

c.

©Yagami Yuu/Media Works/Dengeki Comics GAO!
"ERUFU WO KARU MONOTACHI"

a. This uses a dot tone with the finishing touches like the previous example. The visual direction shows the movement of an instant in this fight scene. Pay attention to the direction of the dots and etch with force.

b. The visual direction of expressing the power emanating from the character can be changed based on the etching of swirls and vortexes in background gradation tones.

c. Adding the sun in the background tone gives it a feeling of stupidity.

d. A grain tone was laid slightly over the characters and etched in the direction of their movement. The visual direction uses a stop motion effect creating a moving scene.

e. Etched with the tip of the cutter giving a smoke effect. The visual direction expresses an ominous sense.

How to Use Illust Tex and Instantex

Illust Tex and Instantex are members of the tone family. These are sheet patterns laid over the page and rubbed to transfer the pattern to the page.

1) Prepare a page.

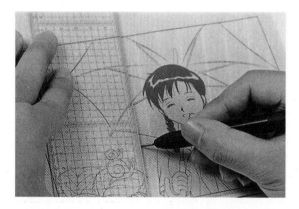

2) Place the sheet over the page and rub it with a tone tool or spatula transferring the pattern to the page.

3) After transfer slowly remove the tone.

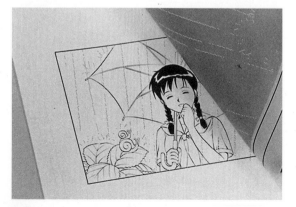

4) Transfer another pattern and create the scene using the pattern together with other tones.

5) Remove unneeded areas with a cutter or lightly hold in place with some tape.

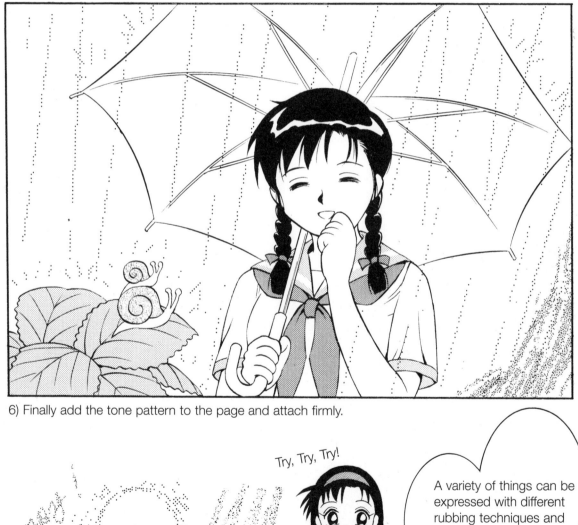

6) Finally add the tone pattern to the page and attach firmly.

Try, Try, Try!

A variety of things can be expressed with different rubbing techniques and touches.

If the areas of pointed tones peel off:
1) Pointed areas of tones peel off easily. Sometimes no matter how hard you paste them on they come off.

2) Try using a clear piece of the tone title area. If the piece isn't big enough, try etching off the lettering.

3) Paste the tone over the peeled off area.

Tone Pasting Ordering
1) When using flashes, sand erasers and the like, start with the background tone.

2) Next do big tones.

3) Then small tones.
If you do small tones before big tones, the big tones when temporarily pasted have a tendency to peel off smaller tones.

1)

2)

3)

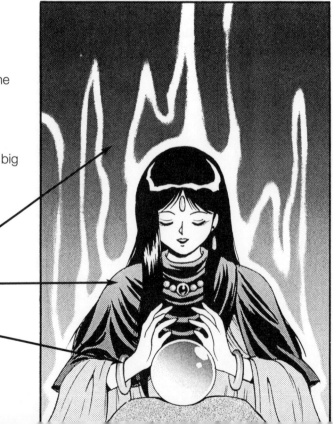

Chapter 3
Expressing Light and Shadows

Light and Shadows in Manga

In the real world, if there is light, no matter how small an object is, it has a shadow. However, manga drawings unlike photographs or paintings, there is no need to faithfully draw the fine details of shadows.

Reasons to add shadows in MANGA are:

a. to add depth of perception and perspective in buildings and the like in the background

b. to add a three-dimensional effect to objects and characters

a.

b.

c. to express the sense of height between the ground/floor under tables or jumping characters

d. to show the presence of objects and characters by adding shadows to the ground and floor

c.

Yippee!!

d.

Peace♡

e. to show the emotional state of the character

e.

ohhh...

Woooow

For the most part, these are for visual direction effects. The amount of shadow is different from person to person based on their judgment. There are an equal amount of people who add shadows to backgrounds but not to characters and who add shadows to both.
However, no shadow at all doesn't make for good manga and too much shadow makes for confused, dark and difficult to see manga.

The same can be said about light.

At night and in dark dim lit rooms the character is dark. But you wouldn't add a dark tone on top, would you?

Making the main character white is one technique.

Other highlight techniques using light:

To bring out the glossiness in hair

While back light makes a shadow on the face, avoid darkening the eyes and mouth.

Use your own sensitivity and judgment when deciding the amount of light and shadows to use. Think about the amount needed for the particular scene or the image you want to express.

To differentiate the outline of people wearing black clothing.

Expressing Shadows and Light in Manga

Look at the shadow of the sphere.

high light - the lightest area

half tone - gradually darkening area

the darkest area

the light area caused by the reflection

shadow of the sphere

While shadows are actually this complex, there is little need for this kind of realism in manga.

Shadows are expressed with tones and pen touches in manga.
When using tones, as a general rule dots and gradation tones are used but you can try other ones.

The shadow was added by simply using a dot tone. The reflected area can be added or not added.

Usually this is enough but etching the tone and shading can be used to better bring out the light.

1) This was lightly shaded using a double pass with the tip and back tip of the cutter.

2) This was sharply etched with a cutter tip and ruler.

This technique gives off a sense that a soft light is striking the sphere.

This technique gives off a sense that a bright light is striking the sphere.

The shadow was done with irregular pen touches on the border with a tone added on top making it look like a bright light is hitting it.

The shadow was done with pen touches on border. Tones can also be used. In this case, shade the border by etching the edge of the tone.

The shadow was done in black with the border done with a brush pen.

The shadow was done by putting a gradation tone over brush pen touches.

Shadows can also be done with net patterns. Shading can be done by changing the density. White was added lining up the border nicely.

Various Methods of Expression

Basic Solid Form Object Shadows

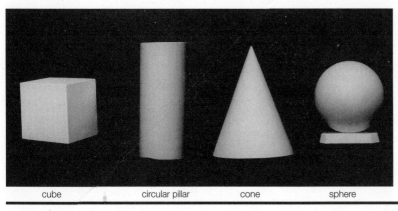

cube circular pillar cone sphere

Earlier we discussed how to draw shadows in manga. Now we'll talk about the basics of how shadows are created.

Take a look at the shadows cast on some basic objects.

The variety of shadow cast on objects depends on the light source.

1) Difference Between Sunlight and Artificial Light

The shape of shadows changes with the distance of the sunlight and artificial light as shown below.

With artificial light

viewed from above

With rays of sunlight

the shadow follows the direction of light making the width wider.

the width of the shadow is unified.

2) Height of the Light Source

The height of the light source is also important. Recall the shadows of noon or dusk. When the source of light is high, shadows are short and when the source is low shadows are long.

light source

1. When light is cast diagonally from the front

vertical line

direction of the light

ground perspective line

Tones and guidelines were added to these drawings.

Take a look at the shadows cast from three angles of light - diagonal from the front, side and diagonal from the back.

The tip of the shadow is circular.

These are the basic objects used in art design drawing. No matter how complex the form of a character or object becomes, by combining the principles of these four objects anything is possible. The important thing is to keep the way shadows are cast from these four objects in your mind.

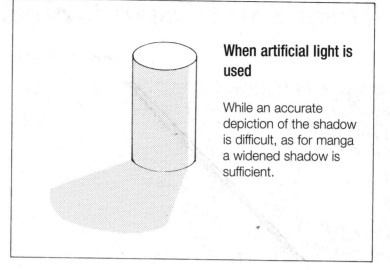

When artificial light is used

While an accurate depiction of the shadow is difficult, as for manga a widened shadow is sufficient.

2. When light is cast diagonally from the sidea

3. When light is cast diagonally from the back

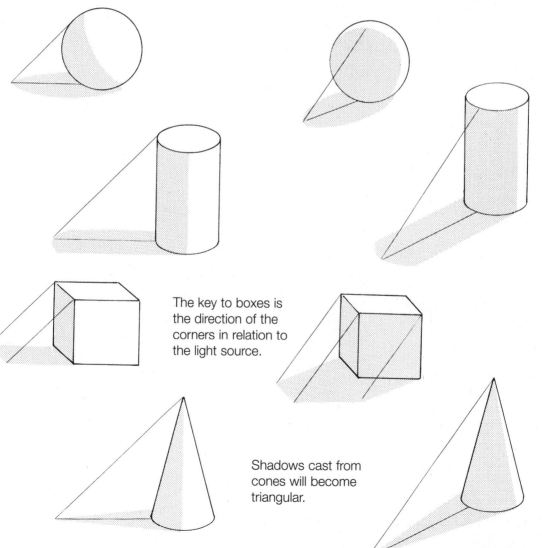

The key to boxes is the direction of the corners in relation to the light source.

Shadows cast from cones will become triangular.

Drawing Shadows on Characters' Faces

Take a look at these examples.

1. light shadow

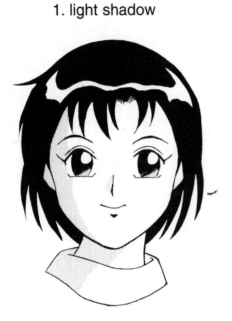

2. middle shadow

Shadows are hard to add to round faced characters. Shadows are often added to the hair and forehead.

3. heavy shadow (back light)

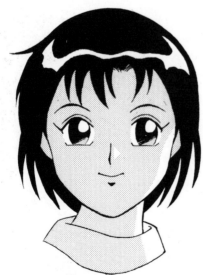

Adding a little light to the nose adds dimension to the character.

4. profile shadow

Light cast from the front of the character

Please use your judgment based on the scene when deciding the amount of shadow to add to characters. Devise your own ways like, when the character is happy try light shadows, or add more shadow at dusk, or add shadows only to close-up shots leaving an impact on your readers. If you think adding no shadows are best then that is fine too.

1. light shadow

2. middle shadow

Since male faces are relatively more clear-cut than female faces, shadows are often added below the eyebrows.

3. heavy shadow (back light)

4. profile shadow

How to Draw Shadows on a Variety of Faces

Shadows done with gradation tones. They make for more impressive drawings than using dot tones.

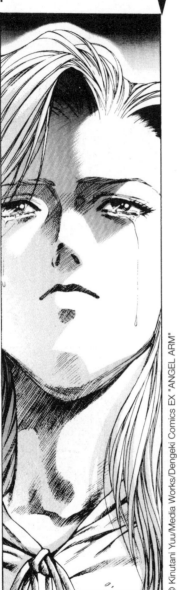

© Kinutani Yuu/Media Works/Dengeki Comics EX "ANGEL ARM"

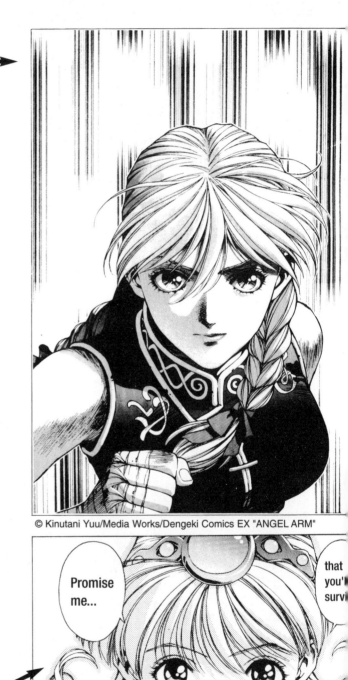

© Kinutani Yuu/Media Works/Dengeki Comics EX "ANGEL ARM"

Using a coarse dot tone puts the finishing touches on a soft scene. Since this example has been reduced and printed the dots are smaller.

©Kinutani Yuu/Enix/G Fantasy "LUCKY RAKUUN"

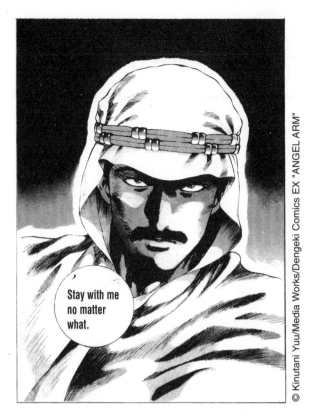

When tones have been previously placed on the face, add shadows by layering tones.

The back light brings a dauntless atmosphere to life.

Shadows from light cast from below

Adding shadows cast from low light emphasizes expressions of anger, fear and the like.

fear

domineering

anger

Shadows Cast on the Body

In this case shadows were expressed using tones.

110

These drawings are merely to bring out the dimensions and are more simplified than actual bodies. In addition, in real life more shadows would occur.

Shadows are but one part of a drawing. Instead of being faithful to reality being faithful to your individual taste using deformed shadows may be more important.

Shadows Cast on Parts of the Body

In real life shadows on the body are complex. Real to life representations can be created adjusting the density of shadows using tones and layering.

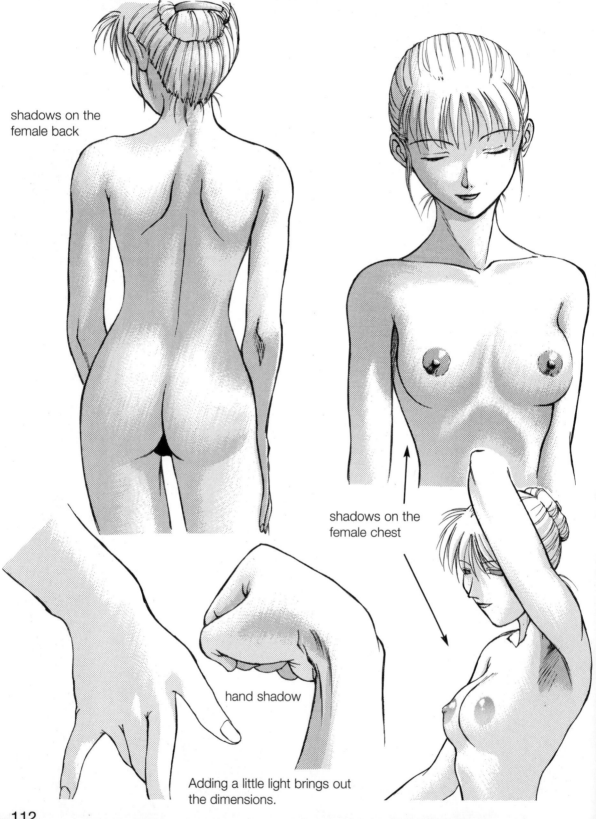

shadows on the female back

shadows on the female chest

hand shadow

Adding a little light brings out the dimensions.

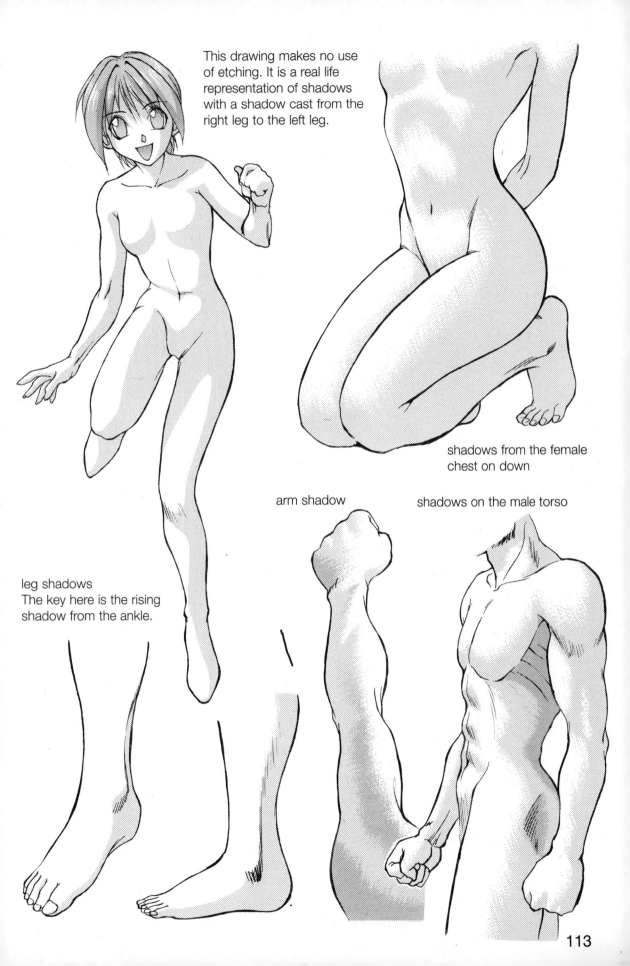

This drawing makes no use of etching. It is a real life representation of shadows with a shadow cast from the right leg to the left leg.

shadows from the female chest on down

arm shadow

shadows on the male torso

leg shadows
The key here is the rising shadow from the ankle.

Shadows Cast on the Ground

In real life, the length of shadows cast on the ground varies with the height and position of the sun.

In addition, the shadow varies with the posture of the character. Let's look at some basic posture examples.

Shadows Cast at Midday

The important thing is that the reader is made aware of the shadows.

For bright summer sunlight, black works fine too.

shadow done with a tone

shadow done with pen touches and net patterns

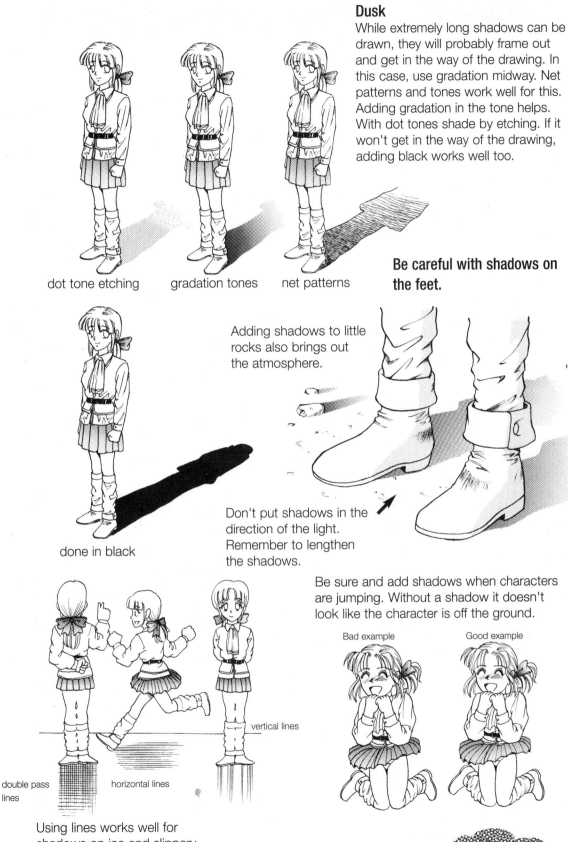

Shadows Cast at Morning and Dusk

While extremely long shadows can be drawn, they will probably frame out and get in the way of the drawing. In this case, use gradation midway. Net patterns and tones work well for this. Adding gradation in the tone helps. With dot tones shade by etching. If it won't get in the way of the drawing, adding black works well too.

dot tone etching gradation tones net patterns

Be careful with shadows on the feet.

done in black

Adding shadows to little rocks also brings out the atmosphere.

Don't put shadows in the direction of the light. Remember to lengthen the shadows.

Be sure and add shadows when characters are jumping. Without a shadow it doesn't look like the character is off the ground.

Bad example Good example

vertical lines

double pass lines horizontal lines

Using lines works well for shadows on ice and slippery wooden floors.

Shadows Cast in Exterior Settings

1) This shadow uses a denser tone than the far off shadows bringing out the perspective.

2) Since tones were previously added to the tree and the roof, shadowing was done by layering the tones.

3) Adding light brings out the dimensions.

4) This is the shadow cast on the ground from the wall. If the light source was from the front, this shadow would not be needed.

5) These are shadows from the characters. These were done in a complex manner to show the hairstyle and flares in the skirt. More simplified shadows are fine too.

6) Shadow under the car. Without this shadow the car floats and doesn't look real. Be sure to shadow here. Dense tones work well.

7) Shadows added to show the roundness of the telephone pole.

8) Shadows cast on the trees and trashcans from the telephone pole. Shadows on small objects far off in the distance do not have to be added.

9) Shadow under the eaves of the house. These shadows bring the eaves forward into the frame.

10) Similar shadows under the window.

11) To bring out the perspective in the distance, the drawing of the building was abbreviated. Shadows can be left out in this case.

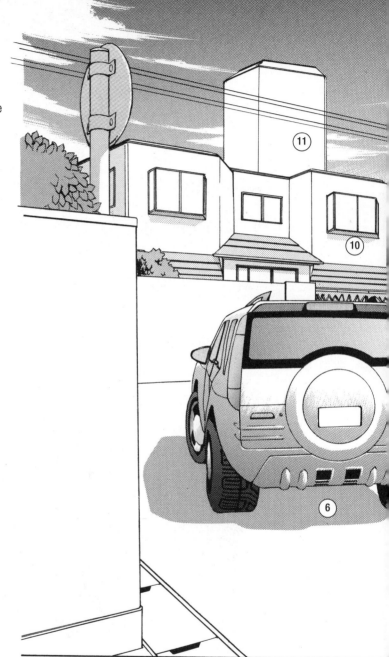

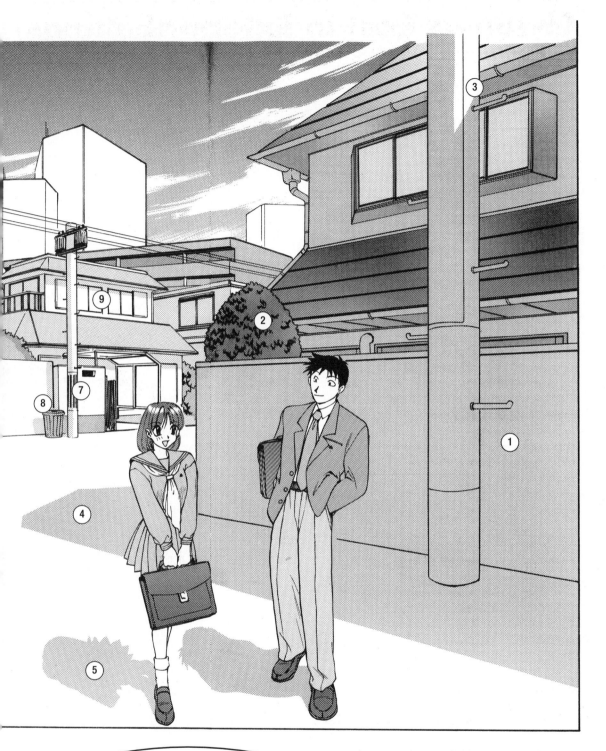

In the real world, no matter how small an object is, it has a shadow.
While this drawing doesn't have the most detailed of backgrounds, it covers the basic points of shadowing.

Expressing Interior Light and Shadows

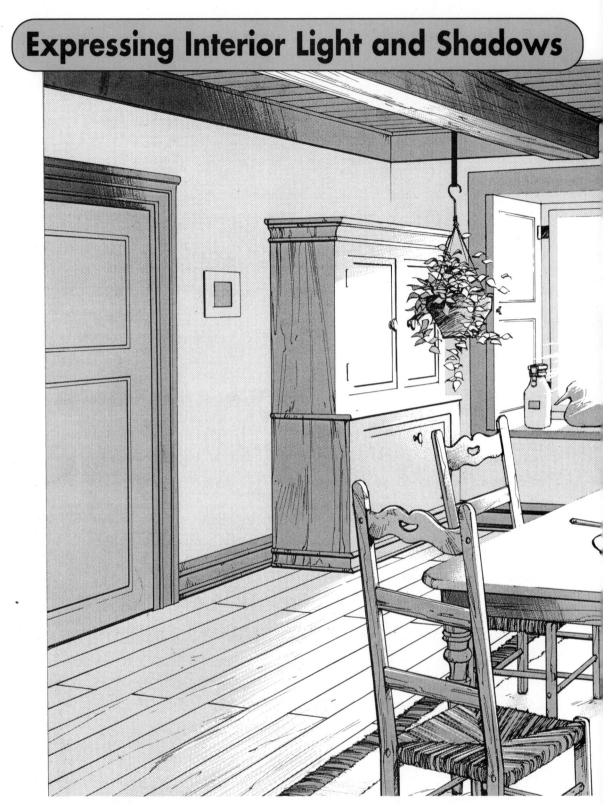

Key techniques are:

Adding tones to the boundary areas brings out the power of the sunlight.

In addition, layering tones emphasizes the light while at the same time adding depth to the drawing.

A drawing expressing the bright, refreshing light of the morning in a room scene.

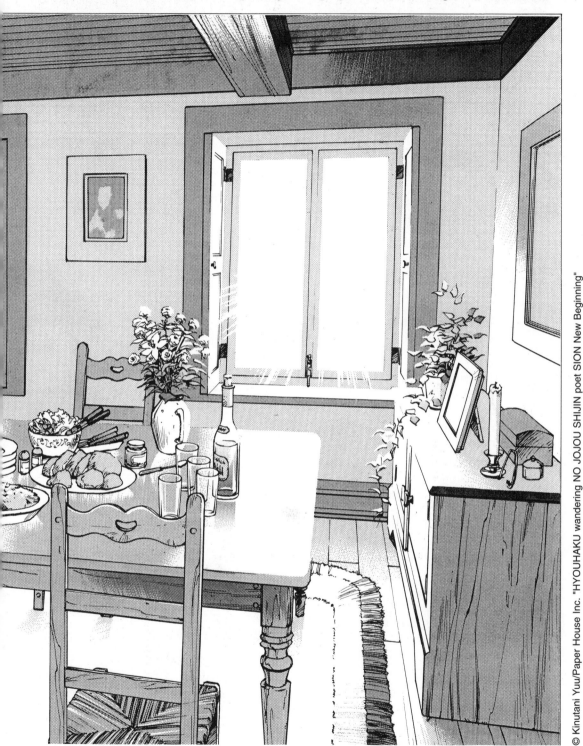

After a tone was pasted the beams of sunlight entering through the window were done in white.

The lines on the table and dresser were not drawn beforehand allowing the strength of the light to be emphasized.